SECOND EDITION

FREELANCE
PHOTOGRAPHER'S
HANDBOOK

SUCCESS IN
PROFESSIONAL
DIGITAL
PHOTOGRAPHY

Cliff and Nancy Hollenbeck

AMHERST MEDIA, INC. ■ BUFFALO, NY

View the companion blog to this book at: http://freelancephotohandbook-hollenbeck.blogspot.com/
Check out Amherst Media's other blogs at: http://portrait-photographer.blogspot.com/
http://weddingphotographer-amherstmedia.blogspot.com/

Published by:
Amherst Media, Inc.
P.O. Box 586
Buffalo, N.Y. 14226
Fax: 716-874-4508
www.AmherstMedia.com

Publisher: Craig Alesse
Senior Editor/Production Manager: Michelle Perkins
Assistant Editor: Barbara A. Lynch-Johnt
Editorial Assistance from: Sally Jarzab, John S. Loder, Carey Anne Maines

ISBN-13: 978-1-58428-266-2
Library of Congress Control Number: 2009903891
Printed in Korea.
10 9 8 7 6 5 4 3 2 1

Table of Contents

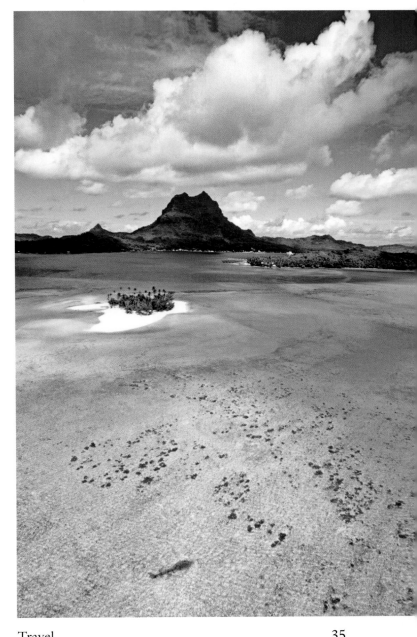

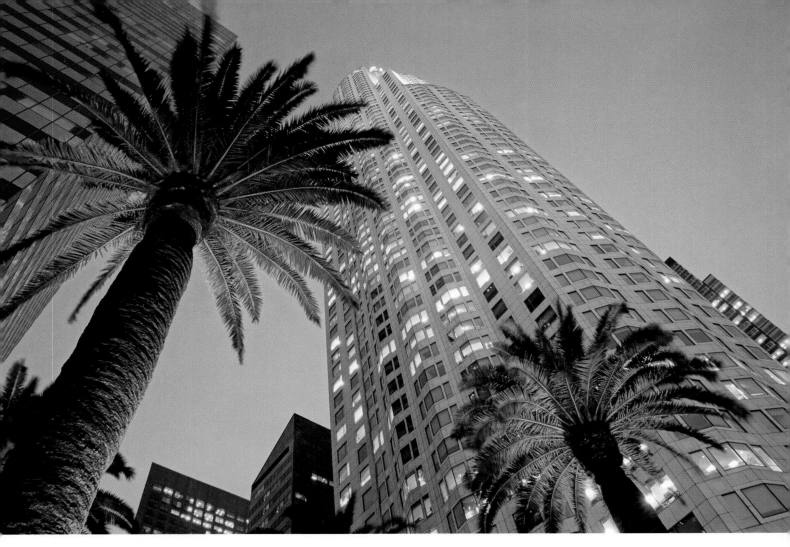

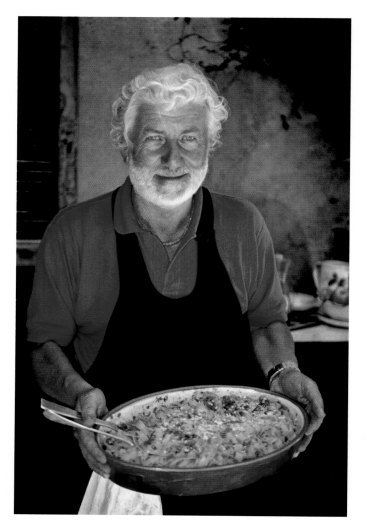

The Authors

Cliff and Nancy Hollenbeck are a leading travel photography and film-making team. They specialize in editorial and commercial image making throughout the world, for major airlines, cruise lines, advertising agencies, publishers, tourism associations and publishers. The Hollenbecks have authored two dozen books on photography, travel and business subjects. Cliff has twice been named "Travel Photographer of the Year" by the Society of American Travel Writers and has participated in several "Day in the Life" book projects. Their film company, which specializes in subjects similar to their still photography, has received gold medals at both the International Film Festivals in Chicago and New York, as well as several Tellys for Travel and Tourism Sales Programs and Commercials.

Introduction

It would be difficult to find an event, occasion, subject, or location in life that isn't the focus of a freelance photographer at one time or another. It is one of the most diverse, interesting, exciting, and fulfilling careers of all. It is also a demanding career that requires a wide variety of skills and a great deal of patience, practice, and productivity.

Everything in this book is aimed at helping you discover (and consider entering) the world of freelance photography—or to improve your current freelance photography knowledge and capabilities. Once you have mastered the contents of this book, which are general and basic in nature, and have decided to make your way in freelance photography, you might want to do some advanced reading in our book *Big Bucks Selling Your Photography, 4th ed.* (also from Amherst Media). Modesty doesn't prevent us from saying that this book is one of the best guides on the market to making your way as a professional freelance photographer.

The digital revolution has opened a whole new world, and means of creativity, in photography and the business of photography. This book is also an introduction to understanding the impact of that revolution, which expands all aspects of freelance photography. The combination of these two exciting worlds is extraordinary.

There is a great deal of joy and satisfaction in the freelance photography world. Its very diversity allows a person to photograph and participate in just about any field, hobby, event, or destination they enjoy. The best part is the ability to do this while making money in the process. The IRS also allows expenses in the professional pursuit of these endeavors to be deducted.

The suggestions and information in this book are based on more than twenty-five years of experience in the freelance photography business. We've tried just about everything that can be tried in the shooting process, the selling process, and the running of a small photography business. We also welcomed the digital world into our business with open arms. If there's anything we've learned about succeeding in the world of professional photography, it is to keep trying new ideas, to keep shooting, and to keep an open mind.

We wish you good shooting, joy, and success in the world of freelance digital photography!

Everything in this book is aimed at helping you discover the world of freelance photography.

1. Welcome to The World of Freelance Digital Photography

A freelance photographer sells their services, products, and images to a wide variety of clients, without a long-term commitment or legal employee status. This circumstance is often loosely termed by many other names, including contracting, subcontracting, licensing, leasing, entrepreneurship, self-employment, and work-for-hire. All too frequently it is also called unemployment. Freelance photographers work for themselves and are considered self-employed. These are the terms used by one of the most important players in everyone's business life: the Internal Revenue Service.

What it Takes to Freelance Today

If you can produce a quality photograph and know your way around a computer, and modern imaging software, you have the initial ingredients to be a

Freelance photographer and author Cliff Hollenbeck is shooting for a swimsuit catalog in the morning light of Cancun, Mexico.

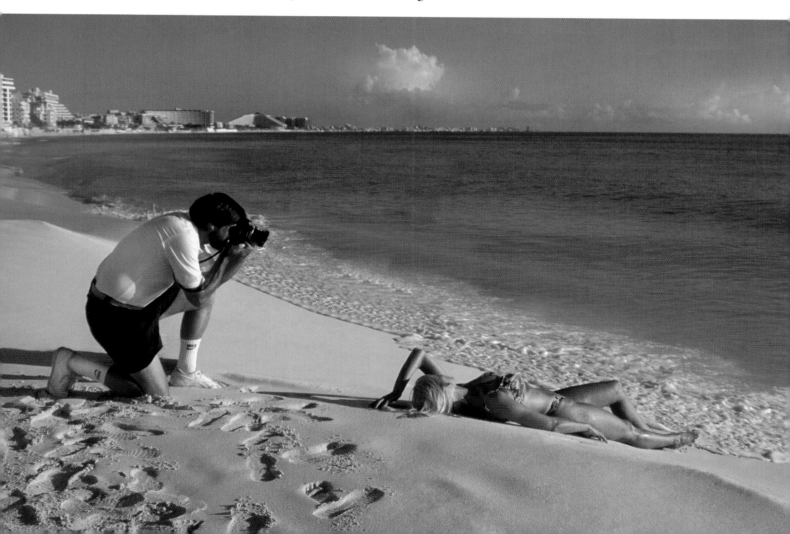

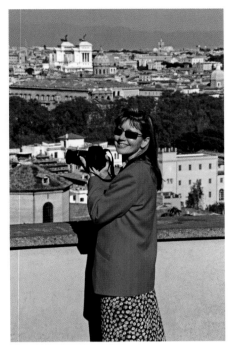

Freelance photographer and author Nancy Hollenbeck making photographs during a travel guide shoot in Rome, Italy.

digital photographer. The strong desire to do this for a living, in a business of your own, is also necessary to become a freelance photographer. It's just that simple—although it's not always as easy as it may sound.

There are a few basics that must also be met to be a *successful* freelance digital photographer. You must do a better-than-average job of providing the following:

- Creative and high-quality photography
- Good and responsive service
- Competitive prices

Starting a small business requires preparation, product and talent development, physical work, financial investment, business knowledge, and determination. Some photographers start a freelance business without giving much thought to some of these important requirements of operating any business. In order to stay in business, and enjoy some of the successes it can provide, a successful freelance photographer must also have the following:

- A creative eye
- A strong commitment
- Lots of persistence
- Good organizational skills
- Planning ability
- A sense of humor

Getting Started

Start planning today if you want to be a freelance digital photographer tomorrow. Start keeping a list of everything you'll need to accomplish, and the important things you hope to learn along the way. That list should be pretty long by the time you've finished reading this book. Don't worry—you'll enjoy learning about and completing most of the basic requirements. Also, talk with your immediate family and friends. You'll need their support and suggestions along the way. If you can sell them, you can sell potential clients and investors.

Your Interests and Specialty

One of the first things you'll need to do is take a good look at the diversity of freelancing opportunities. Is there a particular field of interest that you would like to make the basis of a freelance digital photography business? If you have already made that choice, you'll need some ideas to get started. If you're not sure, turn to chapter 2 and take a look at the many specialties available to freelance photographers. It may help you to make a list of the areas that sound interesting.

Your personal interests (like sports, hobbies, professions, people, and so on) should also be considered. First, ask yourself if you will enjoy spending most of your working life involved with the subjects of your freelance world. For example, if you don't like the subjects portrayed in today's hard news media, then being an photojournalist may not be the best choice. You may prefer covering more general-interest subjects, as a magazine photojournalist would do. Ask yourself if it's possible to make money as a freelancer offering services and products in your potential specialty.

There's no reason you need to rush into making a decision as to which field or specialty you choose. You can also be interested in more than one field at the same time. After all, you will be the boss.

Author Cliff Hollenbeck samples a fine Amarone wine, during a magazine shoot in Valpolicella, Italy.

The Business Considerations

On the business side, you'll need to do a little investigating and decision-making, as well. Ask for help and advice from someone who has a successful small business—preferably not another photographer at first. This person can provide a little direction in forming your new small business. This means talking about obtaining the legal and governmental paperwork as well as the office and marketing equipment needed by any new enterprise. You'll also need to discuss your capabilities and general equipment from a business standpoint.

Once you understand what the world of independent business requires, then you can talk with freelance photographers. We suggest attending meetings of the various professional and photographic societies related to your specialty. Other professionals will be happy to help you get started, because they want their competition to operate in a professional manner, as well.

With a little planning, plus a lot of persistence and organization, most people can learn and master the basics of owning and operating a successful small business. In the end, the work will be up to you. Pass or fail, you'll get the credit.

Where You Can Freelance

Good news. Just as you have a choice about what to photograph as a freelancer, you'll also be able to do it anywhere you want. Clients in the larger markets already have experience working with freelancers of all kinds within the creative and business world. They are already comfortable with freelancers and know the needs their services can fulfill. Most also offer a certain amount of willingness to work with talented and determined new people.

In recent years, technological advances—especially the digital ones—and a global economy have also made it possible to leave the metropolitan centers and still survive as a freelancer. Today's clients rarely see the offices of the photographers they hire. Most selling depends on a national marketing campaign, agents, and e-mail, along with telephone and computer efforts. Well-

established freelancers, with national clients, can literally live and work from almost any location.

In the end, communications, marketing, mobility, and rendering good services will determine your success more than the location from which they originate. There isn't a region, a city of any size, or even a country (for the most part) that can't support the services of a good freelance photographer. The digital age has made it easy to live and work anywhere. Anywhere.

What to Expect as a Freelancer

Expect to work much harder than you plan—much harder than your friends and family think you work or are capable of working. Expect to love the business, despite what's said in the following pages. And at times, expect to hate the business because of what's said in the following pages. Above all, if you expect to succeed, to be creative, and to enjoy your life as a freelance digital photographer, that's exactly what you will do.

Freelance digital photography is a wonderful career. The ability to make quality images, and sell them, will open up hundreds of opportunities during a lifetime. Most successful freelancers wonder why they didn't start working for themselves sooner. The business is addictive, often driving you to work for nothing more than the satisfaction of producing a creative product and seeing it used by an equally creative client. In that sense, being a freelancer will become your master and you will live to shoot and participate in the things that make up your specialty. If your work is not a passion, then you might consider doing something that will instill those feelings and loyalties. However, keep in mind that, as a businessperson, you must also provide a living.

What Not to Expect

Do not expect to love every minute of being a freelance photographer. There are a lot of general business requirements that may not be enjoyable. Paying bills, collecting unpaid invoices, and selling to difficult clients are just a few of the things that do not bring happiness in a small business.

Do not expect immediate success, fame, or riches; you will have to work for the rewards.

Do not expect immediate success, fame, or riches; you will have to work for the rewards. Especially at the outset, you will spend the majority of your time selling, developing, and administrating a new business. In fact, freelancers usually spend more time selling their services and products than on any other single activity. In the beginning, you will probably spend as much as 75 percent of your business time selling. That leaves only about 25 percent of your time to create new images and participate in the things that are your specialty. That reality won't change much even with huge success; even the more successful freelancers usually devote well over half of their time to sales. It's a lot of work—and it's not amazing to hear of an "overnight success" who has, in fact, been in business for four or five years.

Do not expect regularly employed people to understand your crazy notion to start a freelance business in a creative art everyone can "easily" do themselves—or, at least, that they think they can do themselves. About the best you can hope for is their support when business is slow and their congratulations when your work is seen in an unexpected place or media.

Do not anticipate things to be easy. Ever. This is an unusual business with far-ranging requirements. In most assignments, you'll be an outsider—even in situations where you have normally been comfortable. If something can go wrong, it probably will. That's the nature of being your own boss, but that's also going to be your opportunity. Most likely it will be why the client has hired you: to solve their image problems.

The Professional Freelance Photographer

A professional in any business delivers their services or products on time, for the agreed price, and at equal or better quality than promised. These are the basics that allow you to be called a professional by your peers and clients. You must meet these fundamental requirements in every engagement. Every job. Every time. Do so and your reputation, potential income, and survival as a freelancer will be enhanced. Remember that you carry the standard for all photographers on each job. If you act in a professional manner, the business world will show its appreciation and your business will grow.

While the above words and requirements are important, they are only the beginning. As a professional freelance photographer you must be creative in the completion every job. Every photograph must be technically good *and* creative *and* what the client needs. Coming up with new and better ideas for meeting your clients' imaging needs is, in fact, the primary requirement for success. Your talent should be paramount to why you've decided to enter this business in the first place.

You must meet these fundamental requirements in every engagement.

Authors Cliff and Nancy Hollenbeck, along with their motion picture crew, during a shoot in the Yucatan jungles of southern Mexico.

2. Specializing

The specialties of freelance digital photography are as wide-ranging and diverse as the subjects they cover. This chapter will provide some insights on the better-known specialties. Being a freelancer is one of the most exciting careers there is, because it allows photographers to participate in nearly all of the world's professions. While you can't be a brain surgeon or rocket scientist without a great deal of education, you can participate in those professions through your photography. The same goes for a special interest or hobby; there's a possibility for making a living around it with freelance photography. A quick walk through the magazine section of a large bookstore will show you how photography plays an important role in every aspect of modern life.

It might be a good idea to work within a specialty or two at the start of your career.

In the beginning, the most difficult part of freelance photography may be limiting yourself to a single field. While it's possible to be a generalist freelancer, shooting anything and everything that comes down the road, it might be a good idea to work within a specialty or two at the start of your career. This will allow you to become proficient in that area, build a reputation, and, hopefully, succeed in the business world of working for yourself. From this position, you can branch out into other specialties. By then you'll already have the shooting and business talents mastered.

There are about two dozen general fields of freelance photography. As you'll discover, many of these can also be subdivided into sub-specialties. For example, there are nature photographers who specialize in shooting mushrooms, travel photographers who specialize in shooting cruise ships, photojournalists who specialize in weddings, and so on. At the same time, the general fields often overlap each other as well, blurring their customary name.

To help you get a better understanding of the possible careers that are available in freelance photography, we've provided some basic information about the primary fields. Under each category we've listed a brief description of the field itself, general equipment needs, the work of noted photographers to review, places to see the photography, and related professional associations. You'll find that some of the top shooters often overlap into more than one field, as do the places you can see a particular type of photography.

This is very broad information. The more you examine and participate in a given field or specialty, the more you'll find that it probably doesn't always

fit a short description. The information you find here is meant to get you interested in taking the extra steps to becoming an expert in a specialty. As you go along, you'll find there are complete books on most of these specialties, several of which are also listed in the resources section of this book (see page 102). They should be your next step after reading this book. We suggest you Google the photographers and magazines in your specialty to get a more advanced look at what's expected from freelancers.

Note: We know that some of the photographers mentioned in this section are no longer with us. While they may be gone, their work is so good it lives on as an example for your own efforts. All of the photographers mentioned in this section are the best in the world at their specialties.

Adventure

Description. This specialty involves photographing action and extreme subjects, such as glacier skiing, mountain snowboarding, skydiving, survival treks,

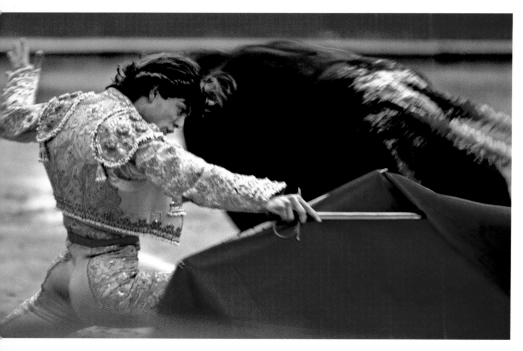

A bullfighter in Guadalajara, Mexico. Made at eye-level with a 28mm–70mm f/2.8 lens that put the photographer close to the action.

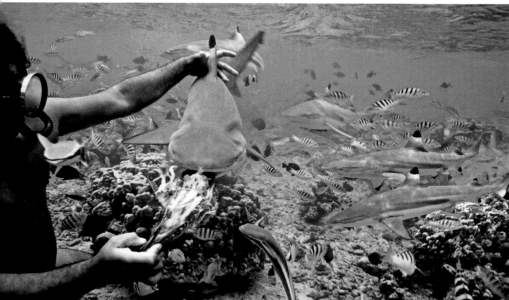

Shark feeding in French Polynesia. Made with a Nikon Nikonos film camera and a 20mm wide-angle underwater lens. Like all adventure photography, getting close to the subject is key to getting good images.

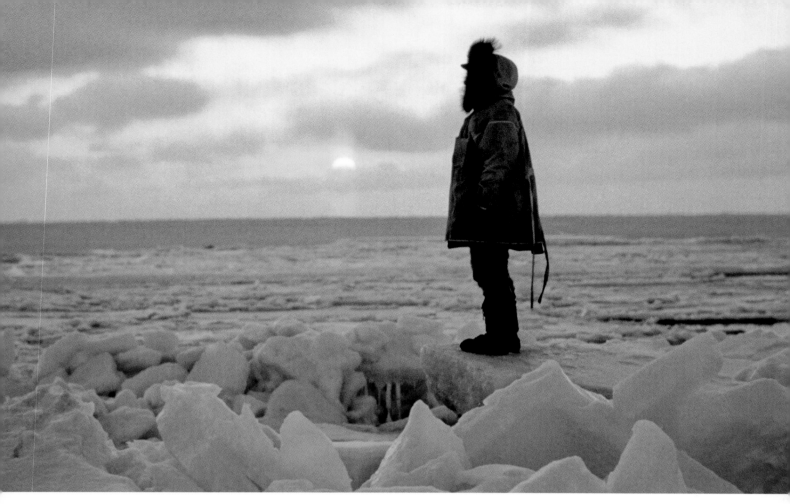

Eskimo whale hunter at Point Barrow, Alaska. Made at high noon with a Leica rangefinder camera that was de-lubed to prevent freezing of the camera's internal parts.

underwater shark hunting, ice diving, white-water rafting, mountain climbing, and anything that might make the reality television programs. There is a much larger specialty in soft adventure, which is aimed at vacationers taking jungle treks, snorkeling ocean reefs, swimming with stingrays, motorcycling the Baja, and so on.

Equipment. Only the most rugged equipment should be used for these specialties, because photographers usually have to participate in the activities to get the shots. The rugged Nikon Nikonos 35mm film camera is one of the better options for harsh weather conditions. Weather and waterproof housings are also available for many digital cameras. A good high-range telephoto zoom lens, multiple-shots-per-second digital camera, and a lot of knowledge or certification within the specialty are also recommended.

Places to See Photography. *National Geographic Adventure, GEO, Outdoor Photographer, Women's Adventure.*

Top Professionals. Aaron Chang, David Doubilet, Chip Maury, Bill Hatcher, David Bailey, Steve Casimiro, Galen Rowell.

Advertising

Description. Advertising photographers make images to sell products, services, ideas, and philosophies. This is one of the broadest fields of photogra-

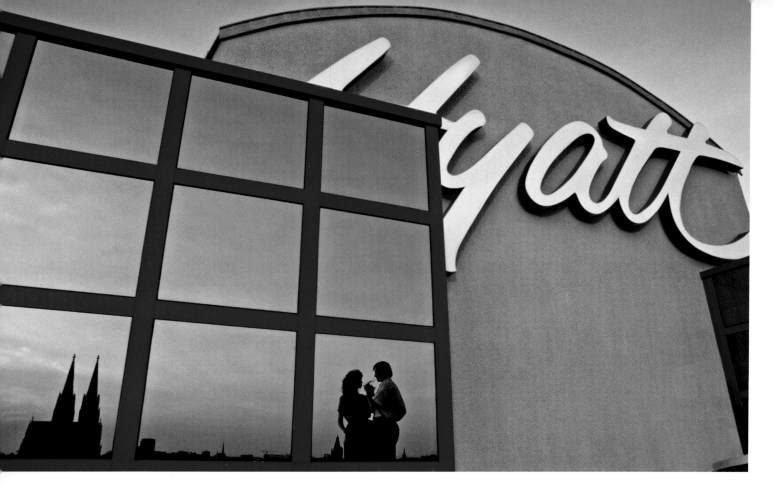

phy, encompassing the worlds of business, industry, and marketing agencies. Photographers often overlap from the other fields.

Equipment. Nearly every type of equipment made is used to produce advertising images. General subjects are photographed with medium-format cameras, such as the digital Hasselblad. Some still-life and tabletop subjects are made with 4x5- and 8x10-inch view cameras that have very high-resolution digital backs. The more mobile and scattered subjects are photographed with good quality and versatile 35mm-style digital cameras. Location computers, extensive lighting systems, and studio-sized tripods are also needed.

Places to See Photography. *Communications Arts, PDN (Photo District News), PRINT,* and in the advertising pages of most magazines and corporate promotional materials.

Top Professionals. Jay Maisel, Pete Turner, Peter Langone, Brian Smith, Chris Callis, Robin Moyer, Kate Turning, Stan Musilek.

Association. Advertising Photographers of America

Aerial

Description. This specialty includes pictures of any subject or location taken from airborne crafts or high stationary platforms.

Equipment. High-resolution, 35mm-style, digital handheld cameras are the most popular. Fast zoom lenses allow shooting several views from a sin-

The Hyatt Regency Hotel in Cologne, Germany, photographed for a brochure. Made fifteen minutes after a summer sunset, with a tripod and a one-second exposure.

FACING PAGE—The Bay at Bora Bora, in French Polynesia. Made from a helicopter at high noon with an 18mm full-frame wide-angle lens.

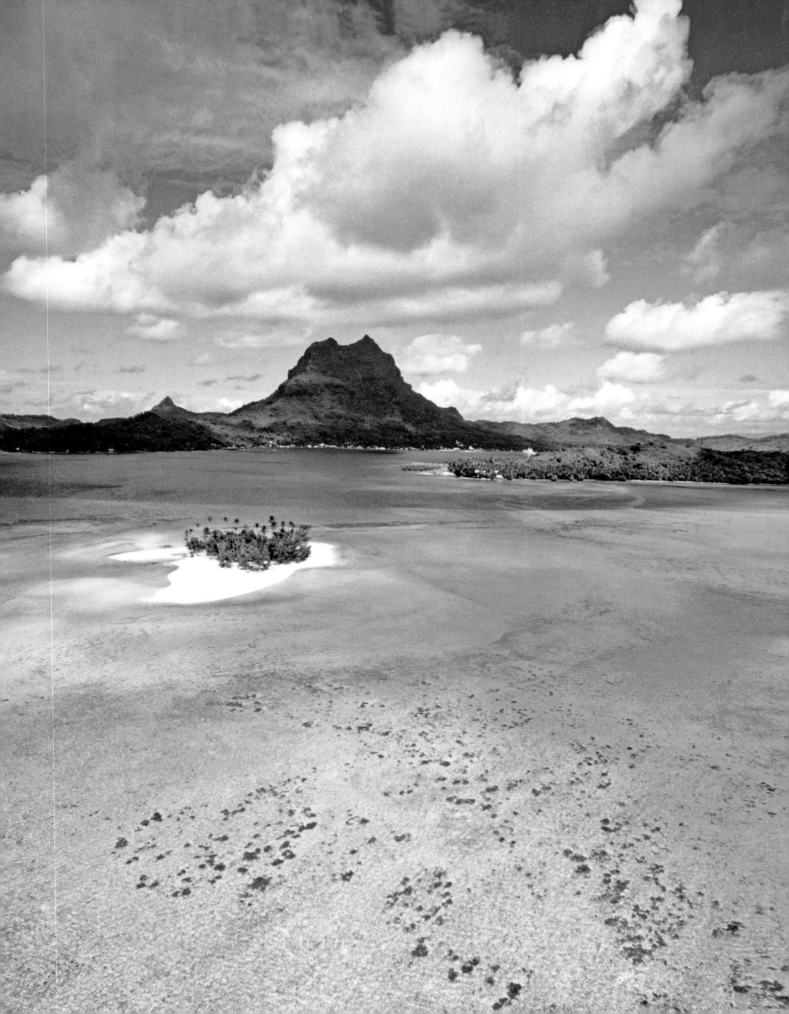

gle altitude. Some aerial subjects require ultra-wide-angle and fish-eye lenses that allow close shooting to subjects and the elimination of haze and pollution. A gyro stabilizer for the camera is also valuable. A secure safety belt is essential. (*Note:* While flight training will add to your capabilities and knowledge of aviation, never fly your own aircraft while shooting photos. A pilot's eyes need to be used to pilot the aircraft, not to look at a very small part of the sky and earth through cameras.)

Special Requirements. Helicopters provide the best shooting platform, although every type of craft from ultralights, to Boeing 747s, to spaceships have been used to make aerial photography.

Places to See Photography. *National Geographic, Flying, Legion, Professional Surveyor,* corporate sales brochures, real estate publications, aircraft sales and lease companies.

Top Professionals. Harvey Lloyd, Jay Miller, Clay Lacy Aviation, Aerial Innovations, AboveAll, George Hall.

Associations. Professional Aerial Photographers Association, International Society for Aviation Photography.

A glider over the island of Kauai, Hawaii. Made from a helicopter in late afternoon, using an 85mm lens.

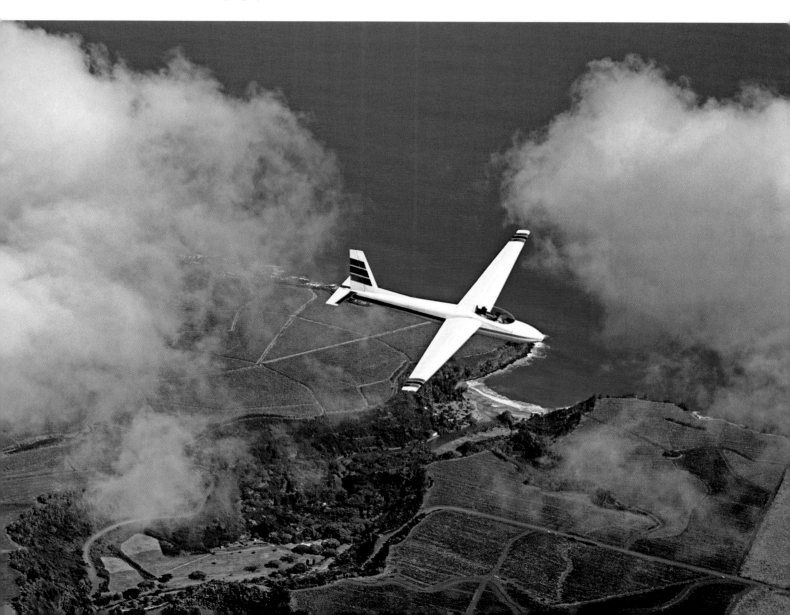

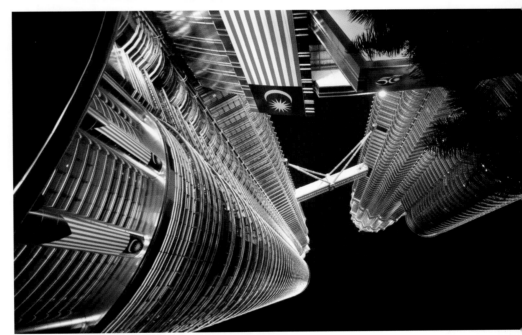

TOP LEFT—The Todos Santos Inn, Baja, Mexico. Made with existing natural light, a tripod and a one-second exposure.

TOP RIGHT—The Presidential suite at Las Brisas, Acapulco. Made with a soft silver fill reflector.

RIGHT—The Kuala Lumpur, Malaysia Twin Towers. Made at night with a 18mm full-frame wide-angle lens, tripod, and a one-second exposure.

Architectural

Description. Architectural photographers create images of man-made structures, usually buildings and homes, both inside and out.

Equipment. Adjustable 4x5-inch (and larger) view cameras with a variety of lenses and very high-resolution backs, multiple strobe- and tungsten-lighting setups, sturdy tripods, and location computers. Some real-estate, travel, and retail consumer organizations use less technically perfect images made with digital 35mm-format cameras.

Places To See Photography. *Architectural Digest, House Beautiful, Veranda, Materia* (Italian), *Interior Design.*

Top Professionals. Brian Vanden Brink, Tim Hursley, Erhard Pfeiffer, Susan Carr, Richard Busher.

Associations. International Association of Architectural Photographers, Association of Independent Architectural Photographers.

Commercial

Description. Commercial photography involves making images for use by retail and wholesale businesses. Business portraits, manufacturing, sales materials, promotions, advertising, and the like are all part of this field.

Equipment. The digital 35mm and medium formats are the most popular cameras. Portable lighting systems, location computers, and sturdy tripods are also needed.

> Commercial photography involves making images for use by retail and wholesale businesses.

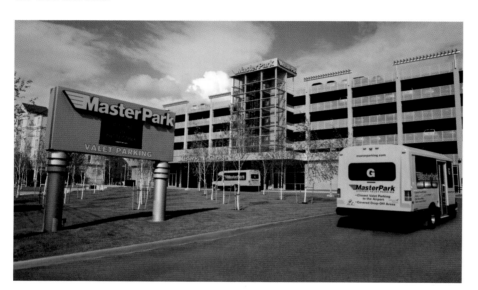

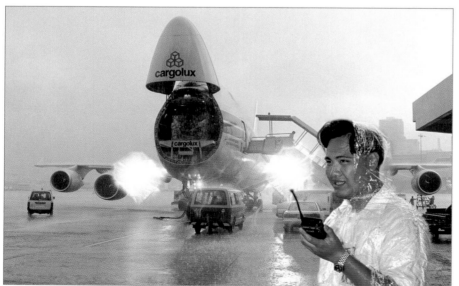

TOP—Commercial photography of the MasterPark facility near Seattle-Tacoma International Airport in Washington State.

BOTTOM—Corporate photography of a Cargolux Boeing 747 jet, and airport ground manager, during monsoon rains in Bangkok, Thailand. Made with on-camera flash-fill and aircraft landing lights.

Places to See Photography. *Fortune, Entrepreneur, Business Week,* business sales flyers, and advertising.

Top Professionals. Gregory Heisler, Steve Krongard, Peter Langone, Mark Robert Halper, Stan Musilek, Jay Maisel.

Associations. Professional Photographers of America.

Corporate

Description. For the most part, this is annual report photography, encompassing executive portraits, manufacturing services, and related subjects of interest to stockholders and the business world.

Equipment. Medium-format digital cameras are the most popular; some 35mm-type cameras are used by the lower-budget clients. You'll need a wide range of lenses, filters, multiple lighting systems, a location computer, and tripods.

You'll need a wide range of lenses, filters, multiple lighting systems, a location computer, and tripods.

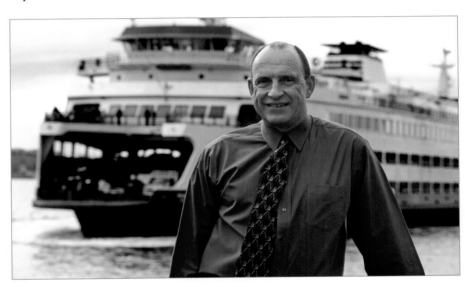

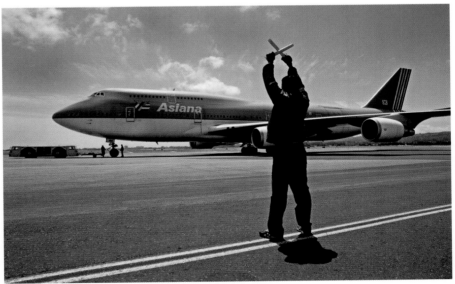

TOP—Corporate portrait of Washington State Ferry official, Michael Anderson. Made with 200mm lens, on-camera flash-fill, and natural light.

BOTTOM—Corporate photography of an Asiana Airlines Boeing 747 passenger jet on the taxi way of the international airport in Seoul, Korea.

Places to See Photography. *Fortune, Inc.,* corporate annual reports, stock sales portfolios.

Top Professionals. Gregory Heisler, Peter Langone, Dana Hursey, Mark Bolster, Robyn Moyer.

Associations. Professional Photographers of America

Entertainment and Celebrity

Description. Entertainment photographers make images of well-known people for promotion and marketing. This is often done on film sets, in recording studios, in private homes, and at photo studios. With a few exceptions, the paparazzi are generally considered editorial photographers and do not work within the entertainment industry; they work for the entertainment media. (*Note:* Access is everything in this field, which means being well-connected and having a good agent.)

Equipment. Digital 35mm cameras, motor drives, zoom lenses, and sound-proof housings are needed.

Places to See Photography. *People, Detour, TV Guide, Rolling Stone, Vanity Fair, The Hollywood Reporter, Variety,* CD/DVD covers, movie-theater advertisements.

Top Professionals. Douglas Kirkland, Michael Grecco, Annie Leibovitz, Peter Langone, Matthew Jordan Smith.

A musician in concert at the Hollywood Shell, California. Made with a 28mm lens, using a stage spotlight, at ISO 800.

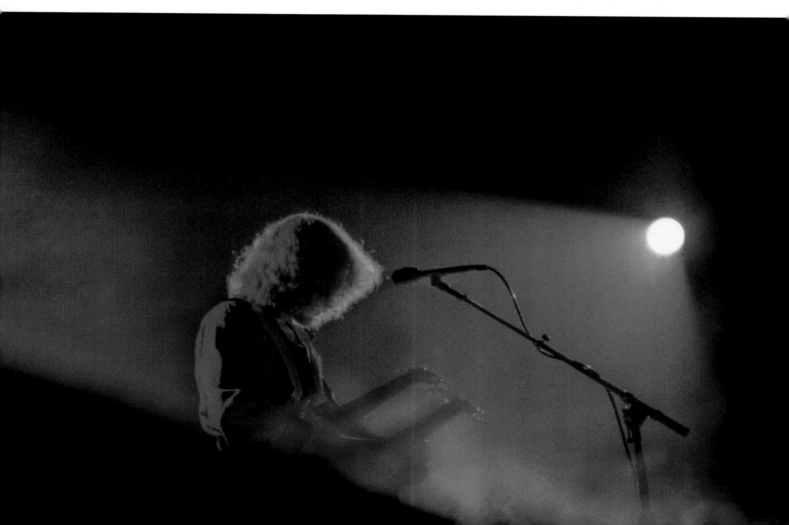

Medical evidence photography. Made with a 28mm lens and an operating room light at ISO 500.

Fashion photography at the Ixtapa Brisas Resort, Mexico. Made with soft silver fill reflectors and natural light.

Evidence and Forensic

Description. This field entails photography of crime scenes, accident scenes, and related evidence for legal firms, insurance companies, law enforcement agencies, and medical labs.

Equipment. Specialized and adapted digital photography equipment is required for this field. Reviewing their professional association's web site (see below) is a must when considering any equipment purchases.

Associations. Evidence Photographers International Council, International Association for Identification.

Fashion

Description. Fashion photographers produce images that sell and promote clothing, shoes, jewelry, makeup, and related items.

Fashion photography of a swimsuit model in Puerto Vallarta, Mexico. Made with on-camera flash-fill and a gold reflector.

Equipment. Digital 35mm and medium-format cameras, with a wide range of high-speed lenses, and multiple lighting systems are needed.

Places to See Photography. *Elle, Detour, Jane, Vogue* and *Italian Vogue, Glamour, GQ, Modern Bride, Brides.*

Top Professionals. Andrea Giacobbe, Chris Callis, Sean Ellis, Francois Nars.

Fine Art

Description. Fine-art photographers create artistic images for the walls of homes and offices, the collections of serious photography and art aficionados, and advertising materials.

FACING PAGE—Fine art photography of Spanish spurs on a sheet of slate. Made with a single softbox studio strobe light and sheet of 85 EF filter gel.

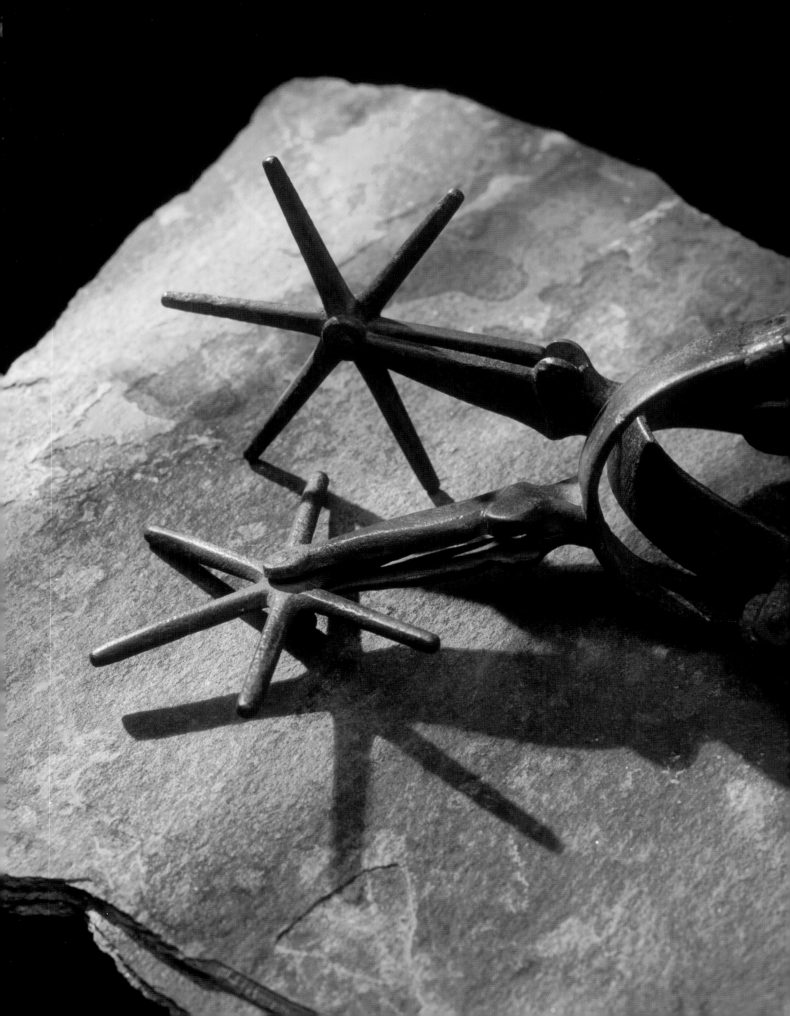

Equipment. All types of equipment are used in this diverse field.

Places to See Photography. *Aperture, Zoom, F-Stop, Camera Arts.*

Top Professionals. Jay Maisel, Eric Meola, Brett Weston, Ansel Adams, Michael Kenna, Richard Misrach, Andrea Giacobbe, Kate Turning.

Glamour and Boudoir

Description. Glamour and boudoir photographers create images of beautiful people, in sensual, exotic, and erotic situations. There is also a large specialty in boudoir portraiture, usually done through portrait studios. (*Note:* There is a huge subfield in the sex [or pornography] industry. Most of that photography is quick and dirty—if you'll excuse the expression—and requires opportunity, motivation, and a market far more than it requires talent.)

Equipment. Digital 35mm and medium-format cameras are used. *Playboy* magazine is one of the few holdouts using large-format cameras in this field. Studio lighting equipment, location computers, and tripods are also needed.

Models in a Hawaiian fresh water stream on the island of Maui. Made with two softbox flash-fill lights, aimed through nearby tree leaves to create shadows.

TOP LEFT—Industrial photography of a welder in a Mexico City factory. Made with the light of the welding and on-camera flash-fill.

TOP RIGHT—Industrial photography of a gravel pit. Made with natural sunset light and a wide-angle lens.

RIGHT—Seattle Steel Mill, Washington State. Natural light was provided by the molten steel, with the camera set at ISO 800.

Places to See Photography. *Playboy, Sports Illustrated, FHM, Detour, Glamour.*

Top Professionals. Barry O'Rourke, Robert Alvarado, Peter Gowland, Rolando Gomez.

Association. International Glamour Photographers Association.

Industrial

Description. Industrial photographers produce location photography of manufacturing, assembly, mining, and similar production plants, as well as the products produced.

Equipment. You'll need digital 35mm and medium-format cameras, a wide range of lenses, portable lighting setups, a location computer, and tripods.

Places to See Photography. Corporate annual reports and sales materials, *Business Week, Popular Mechanics, Industrial Electronics, Industrial Engineer.*

Top Professionals. Mark Bolster, Peter Tenzer, Eugene Mopsik, Mike Dupont, Vince Streano.

Military

Description. Any military activity is covered by these specialists—combat, portraits, news stories, underwater and aerial images, promotions, training, and machinery are among the diverse subjects. (*Note:* It's difficult to be a civilian "freelance" military photographer without having been in the military and/or having some good connections. The armed forces have some excellent in-house photographers, because the military has some good photogra-

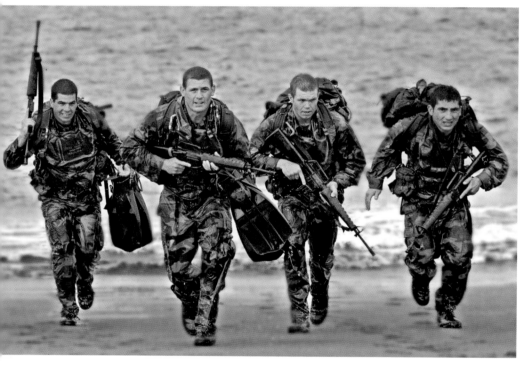

Military photography of U.S. Navy SEALs training at Special Warfare bases around Coronado, California.

phy schools and training programs, which we highly recommend if you want to pursue this specialty.)

Equipment. Any equipment used in any of the photo fields is seen in military photography.

Places to See Photography. *ARMY, SeaPower, Air Force, Undersea Warfare, Marine Corps Gazette, Military,* news and feature magazines.

Top Professionals. Mica Clare, Chad McNeeley, Bobby Richard McRill, Chip Maury, Eddie Adams.

Photojournalism (Feature)

Description. Feature photojournalists are human-interest storytellers who photograph interesting, popular, and political subjects. While this specialty is considered "soft" news, it has produced some very talented Pulitzer Prize winners.

Equipment. Digital 35mm cameras, fast lenses of all focal lengths, motor drives, lightweight strobe systems, and tripods are used.

Places to See Photography. *National Geographic,* airline in-flight magazines, *Smithsonian, Day in the Life* pictorial books.

Top Professionals. David Burnett, David Allen Harvey, Eli Reed, Jody Cobb, Jay Dickman, Rick Smolan, Tom Tracy, Joyce Tenneson, Colin Finlay, William Albert Allard, Catherine Karnow.

Associations. National Press Photographers Association, American Society of Media Photographers, Wedding Photojournalists Association.

Feature photography of cowboy on horseback at Pine Creek Ranch, in central Nevada.

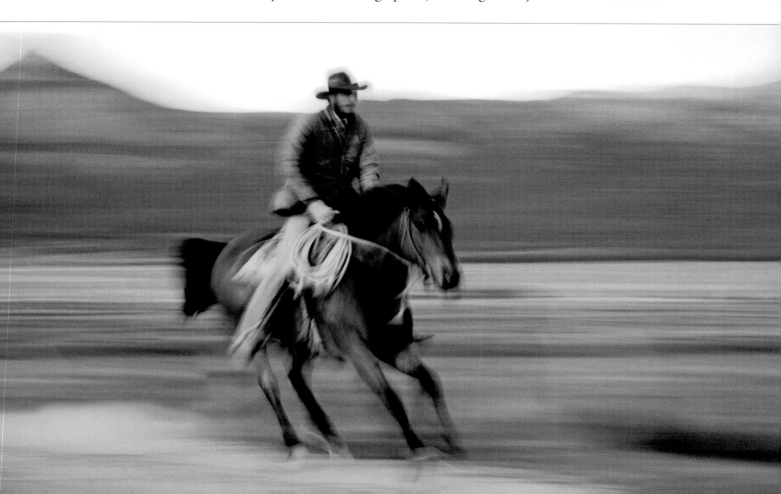

Photojournalism (News)

Description. A news photojournalist is a journalist with a camera, covering hard news stories and current events. This is the domain of politics, wars, and front-page subjects.

Equipment. This type of work is always done with digital 35mm cameras with high frame-per-second rates. Fast (large maximum aperture) wide-to-telephoto zoom lenses, travel cases, satellite cell phones, portable computers, and nerves of steel are also needed.

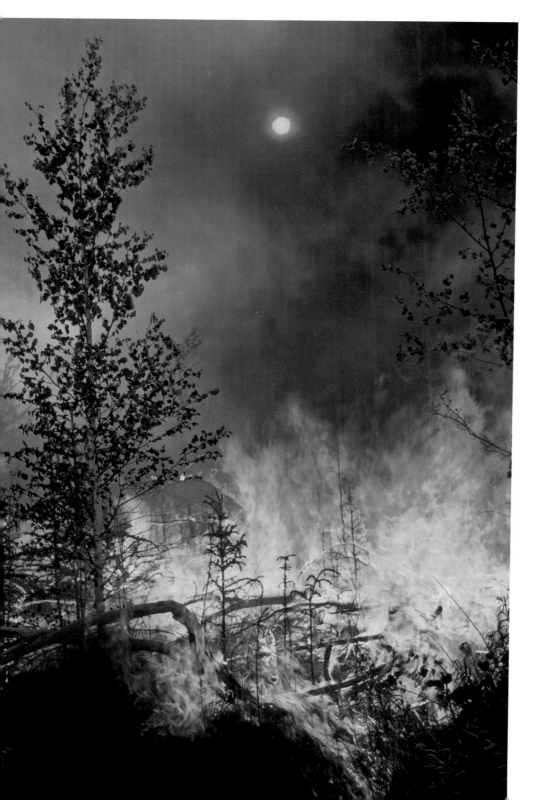

News photography of a forest fire near Circle, Alaska. Made with an 18mm full-frame wide-angle lens, placing the photographer closer to the action for a more dramatic scene.

Places to See Photography. *Time, Newsweek, U.S. News and World Report, Rolling Stone.*

Top Professionals. P. F. Bentley, Dirk Halstead, Robin Moyer, Jay Dickman, Eli Reed, Eddie Adams.

Associations. National Press Photographers Association, American Society of Media Photographers.

Portraiture and People

Description. Formal and environmental portraits of people and families.

Equipment. Medium-format digital cameras, longer lenses, studio lighting, and larger lighting setups are used. For location photography, digital

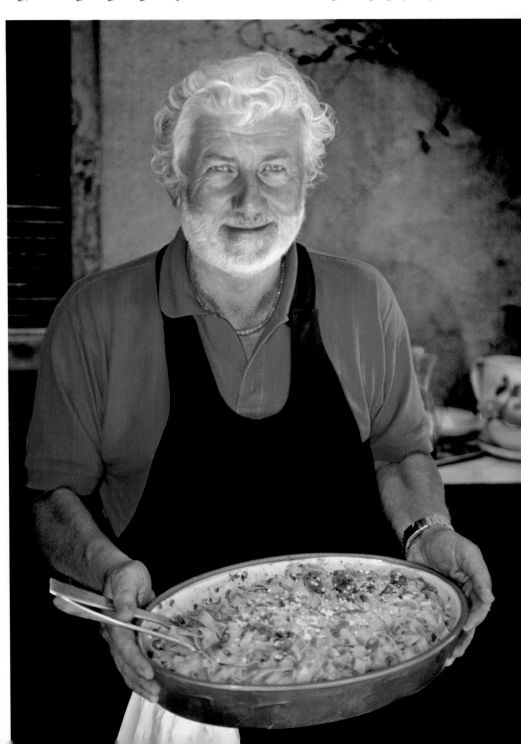

An environmental portrait of a pasta chef in Southern Tuscany, Italy. Made with natural afternoon light at ISO 500.

35mm cameras, normal-to-telephoto zoom lenses, portable lighting equipment, and reflectors are common.

Places to See Photography. *Town & Country, Rangefinder, PPA Storytellers, Vanity Fair, People, GQ, Robb Report, Modern Bride, Brides.*

Top Professionals. Annie Leibovitz, Anthony Edgeworth, Stephen Crain, Mike Libutti, Lord Patrick Lichfield, Gregory Heisler, Douglas Kirkland, Peter Langone, Michael Grecco, Colin Finlay, Chris Callis, Suzanne Maitland, Carl Caylor.

Associations. Professional Photographers of America, Association of Portrait Photographers International, Wedding and Portrait Photographers International.

Sports

Description. Sports photographers document athletic events in much the same way as photojournalists cover news and feature subjects. (*Note:* Knowledge of the sports being covered is essential.)

Equipment. Digital 35mm cameras with high frames-per-second rates are standard. You'll also need a a wide range of fast (wide maximum aperture) lenses and some portable lighting.

Places to See Photography. *Sports Illustrated, Surfing, Outside,* www.sportsshooter.com.

A surfer on the island of Kauai, Hawaii. Made with 18mm full-frame wide-angle lens and natural late afternoon light.

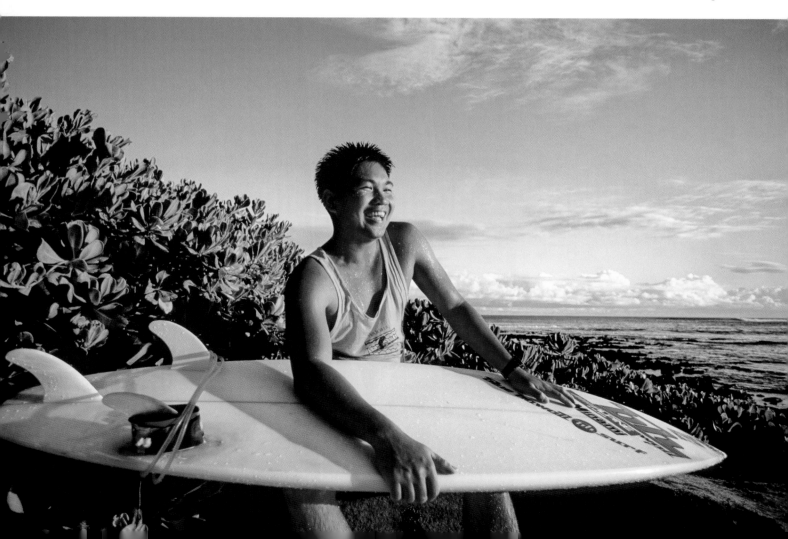

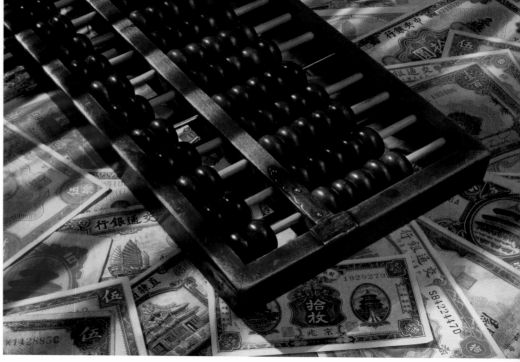

Stock photography of foreign money and abacus counter. Made with studio softbox strobe light directed through window shutter to create shadows.

Stock photography of sea shells and hand at Waimea Beach on the Hawaiian island of Oahu. Made with natural light and a telephoto lens in close-up mode.

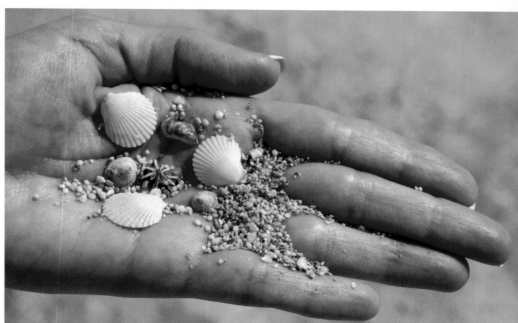

Top Professionals. David Walberg, Peter Read Miller, Ron Modra, Aaron Chang, Tony Demin, Bob Jacobson, Chip Maury, James Williams, Rich Clarkson.

Associations. Society of Sports and Events Photographers, Sport Photographers Association of America

Stock

Description. Stock photographers produce libraries of photos for all common and specialty subjects. Professional stock photography includes images from every other specialty.

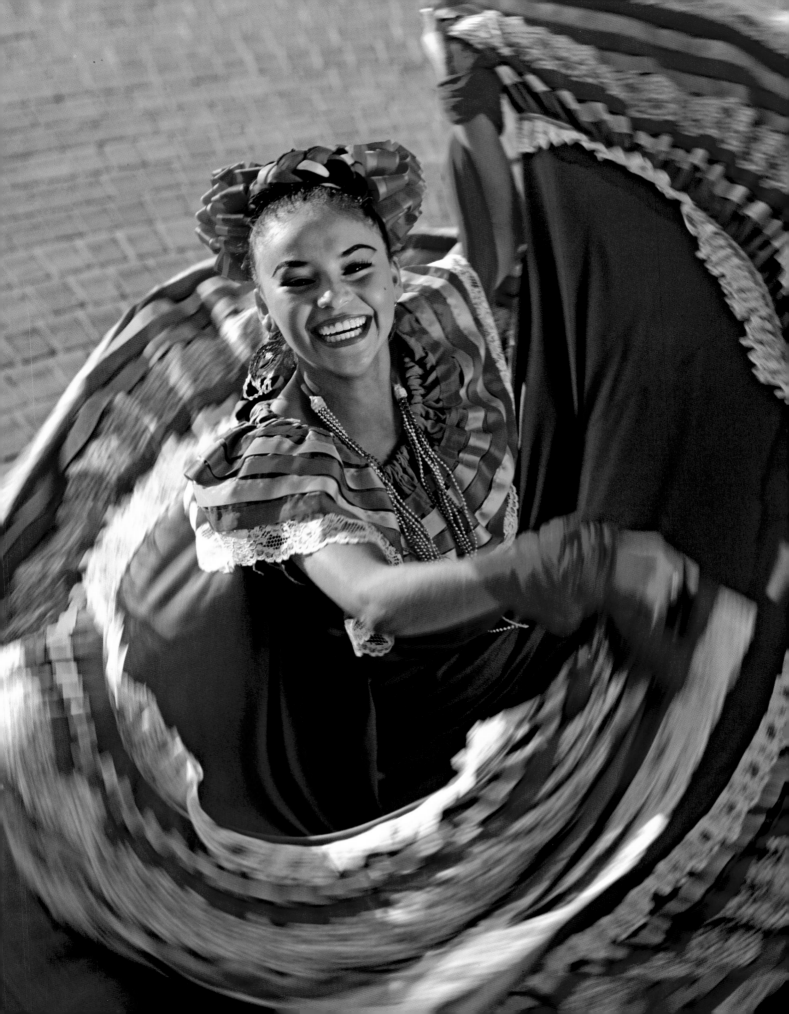

Equipment. See the photography specialty.

Places to See Photography. Corbis, Getty Images, Black Star, Punch Stock.

Top Professionals. The top professionals in every photography specialty are usually the top sellers of stock images as well. Some of the more prolific, high-quality stock photographers are Tom Grill, Jim Pickerell, Brian Peterson, Peter Langone, Michael Agliolo, and Rolf Hicker.

Associations. Stock Artists Alliance.

Travel

Description. Travel photographers produce pictures to promote travel destinations, travel organizations, recreational activities, food, and wine. (*Note:* A good knowledge of geography, languages, and weather patterns is helpful in this field. Travel photography often overlaps into aerial and underwater, sub-zero, and tropical subjects, as well.)

Equipment. Lightweight 35mm digital cameras are preferred. Zoom lenses, portable lighting, tripods, GPS, and compass are also needed.

Places to See Photography. *Islands, National Geographic Traveler, Saveur, Diversion,* airline in-flight magazines, resort and travel publications.

Top Professionals. Peter Langone, Jody Cobb, Erhard Pfeiffer, Bob Krist, David Muench, Paul Chesley, David Burnett—and of course, Cliff and Nancy Hollenbeck.

Associations. Society of American Travel Writers.

FACING PAGE—A folkloric dancer in Jalisco, Mexico. Made with on-camera flash-fill and camera set at a slow shutter speed to create some motion.

BELOW—Travel photography of a pier in Rangaroa, Society Islands. Made with a 14mm full-frame wide-angle lens, in the late afternoon light.

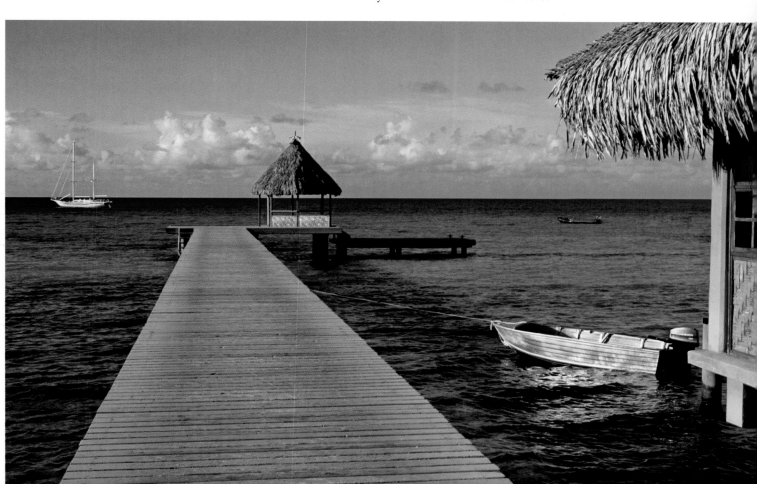

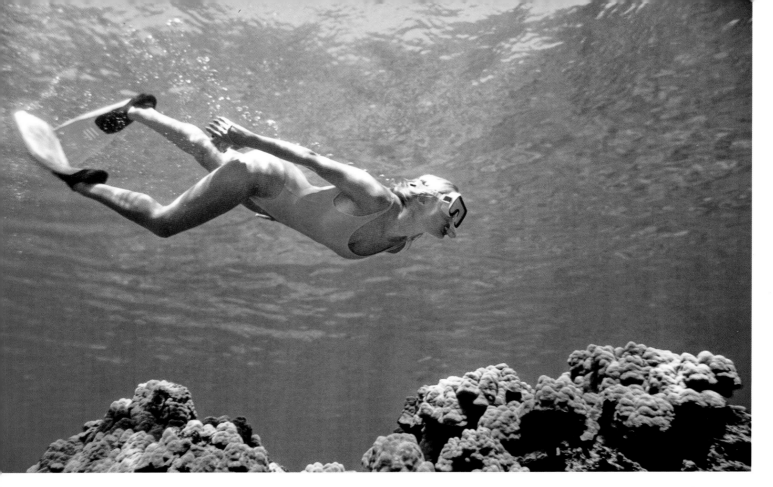

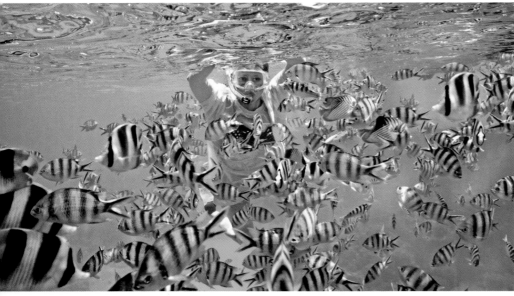

ABOVE—Underwater travel photography at Kona, Big Island of Hawaii. Made with digital Nikon and 15mm wide-angle lens in an underwater housing, and a full-powered strobe light.

LEFT—Underwater travel photography at Current Island, Bahamas. Made with Nikon Nikonos film camera and a 20mm wide-angle underwater lens and natural light.

Underwater

Description. Underwater photos are made of travel destinations, recreation, construction, marine, and submarine subjects. (*Note:* Advanced Diver Certification and experienced dive-partner assistants are a must.)

Equipment. You'll need digital 35mm cameras, wide-angle and normal lenses, underwater camera housings, underwater flash and fill lights, as well

as professional diving equipment. The rugged Nikon Nikonos 35mm film camera is still very popular.

Places to See Photography. *National Geographic, Skin Diver, Sport Diver, Underwater Photography,* oil industry publications.

Top Professionals. David Doubilet, Cathy Church, Steven Frink, Jack and Sue Drafahl.

Associations. British Society of Underwater Photographers, Professional Association of Diving Instructors, National Association of Underwater Instructors. Numerous underwater photo societies can also be found on the Internet.

Wedding and Event

Description. Engagement and wedding photography, conferences and conventions, and a wide variety of other types of events are documented by these photographers.

Equipment. Digital 35mm-format cameras, medium wide-to-telephoto lenses, and portable lighting are used.

Places to See Photography. *Modern Bride, Brides, Meetings & Conventions, Special Events.*

Top Professionals. Pye Jirsa, Giovanni Lunardi, Brian Peterson, Victor Dorantes, Monte Zucker, Melanie Nashan.

Associations. Professional Photographers of America, Wedding and Portrait Photographers International, Wedding Photojournalists Association.

Wedding photography along the Pacific Ocean in Southern California. Made at sunset with an on-camera flash-fill and a soft-focus filter.

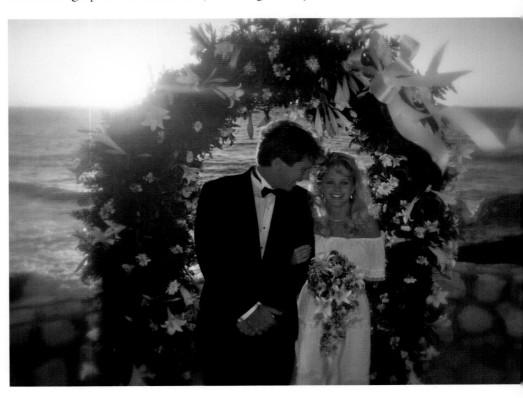

Wildlife and Nature

Description. Animals and natural locations are the the focus of this specialty. (*Note:* A good knowledge of field navigation, weather, survival, and zoology is helpful in this field.)

Equipment. Digital 35mm cameras, telephoto and super-telephoto lenses, and sturdy tripods are common.

Places to See Photography. *Audubon, National Wildlife, National Geographic, Smithsonian, Outdoor Photographer, Wildlife Conservation.*

Top Professionals. Art Wolfe, Joe McDonald, Tim Davis and Renee Lynn, John Shaw, Darrell Gulin, Daniel Cox.

Associations. North American Nature Photographers Association.

Which Specialty?

After reading all the specialty descriptions, associations, and leading professionals, you may have trouble deciding which is best for you. That's not really a problem, because you can experiment with creating digital images in more than one of these fields until something works. And, if that doesn't settle your specialty, you can do what many stock photographers chose to do, as we mentioned earlier in this chapter, and shoot images in any field that catches your interest—whenever something catches your interest. The main thing is to shoot lots of images while you're making a decision.

Bald Eagle in Ketchikan, Alaska. Made with 500mm telephoto lens and natural light.

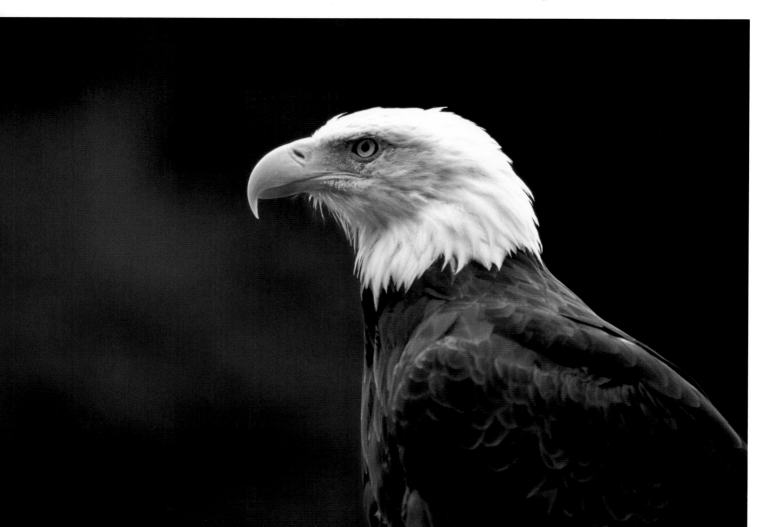

3. The Technology of Photography

The first thing you need to know about, and the last thing you want to worry about, are the tools of freelance digital photography—and there are lots of tools that need to be considered. Cameras, lenses, computers, software, office equipment, and the like are at the heart of creating and selling freelance digital photography. The more you know in advance of doing business and shooting images, not to mention making a business purchase, the more chance there is for creating and selling digital images successfully.

Changing Technology

Technology will always be way ahead of the real photography world. That means something new and very exciting will inevitably come on the market right after you purchased what will suddenly become the "previous" model. This new item will also make the price of your expensive "previous" model drop by half within a few weeks of your purchase. You can't let this drive you crazy—after all, cameras don't create photographs. Photographers create pho-

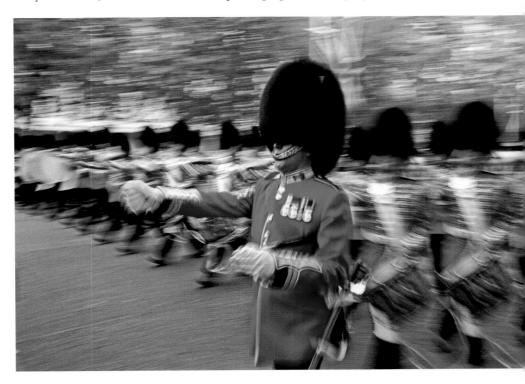

Technology will always be way ahead of the real photography world. Your focus needs to be on creating great images, not shopping for the latest gear. Here, the camera was panned to capture the motion of the Changing of the Royal Guards in London, England.

tographs. You need to concentrate on making interesting and creative images with good-quality, well-maintained equipment that you know how to use. It's not necessary to buy every new gadget, software program, computer system, or hand-held mini-thingy that comes on the market.

Camera Equipment

Every field of digital photography has its own specialized equipment needs, although most use a basic system for the basic subjects. In order to be a successful freelancer you must have the correct equipment to create the images. If at all possible, do not scrimp on your principal working equipment.

The cameras, lenses, lighting equipment, tripods, and related equipment you use must meet two important standards. First, each of these items must be the proper tool for the job; second, they should be the best tools that are available. Professional freelancers do not "make do" by using a low-cost, lower-quality camera to shoot an architectural subject when an adjustable view camera is clearly what's required. They don't use a plastic bag when an underwater housing is needed. Maybe these are too obvious as examples, but they make the point that you should not be substituting because you don't have the proper tool.

Each of these items must be the proper tool for the job . . .

Your equipment should be the best available for the job at hand. It should be in excellent working condition. Do not depend on worn-out, faulty, or second-rate equipment. You should treat and maintain your equipment like a skydiver does—as though your survival depends on that equipment . . . because it does. As those skydivers say, "Make sure your parachute doesn't let you down."

In short, you must have the basic equipment required to make the images you are hired to produce. You wouldn't patronize an auto-repair shop if the

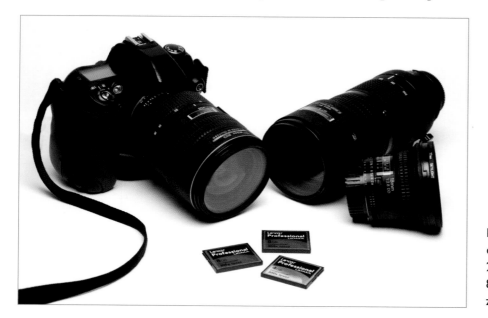

Basic freelance photography equipment: digital SLR; 18mm f/2.8 full-frame lens; 28mm–70mm f/2.8 zoom lens; 80mm–200mm f/2.8 semi-telephoto zoom lens; three large memory cards.

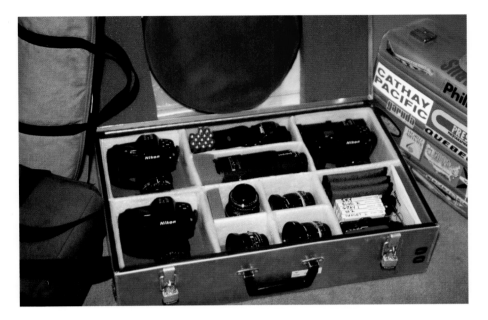

Basic freelance travel case and equipment. A custom aluminum flight case holds three cameras, eight lenses, several filters, several memory cards, an on-camera flash, a collapsible silver reflector, and miscellaneous accessories.

Ask other professionals in your field what equipment they rely on for specific jobs.

mechanic didn't have the tools necessary to fix your car, so don't expect your clients to be "understanding" if you don't have the panoramic camera needed to shoot their billboard image. Professionals should also have backups for every item they use on a regular basis.

Equipment Manufacturers. Name-brand products, equipment, and materials are usually the best choice for freelancers. This equipment can be trusted, and it comes with guarantees. Find a good, solid brand of equipment—such as Nikon or Canon—and stick with it for everything. While off-brand lenses may be cheaper than your camera-maker's lenses, there's probably a good reason. A good system is made to be compatible throughout the manufacturer's range of equipment and accessories. Everything works with everything else, turns the same way, and gives the same results.

After reviewing and researching the particular field of photography or specialty you're interested in, you will also know what's needed in terms of equipment. However, you should not rely on advertising campaigns to find out which equipment is the best for your needs. Instead, ask other professionals in your field what equipment they rely on for specific jobs. Visit professional photo equipment stores to look at, and rent, the equipment you plan to purchase. Attending seminars and conferences given by working professional can also save you a lot of time and mistakes. After all, they've probably already made all the mistakes that can be made—and most are willing to share their findings. You can also surf around the many photography forums and equipment-review web sites. Chances are, someone else has already done the trial-and-error work and written a review.

Where to Buy. When you are ready to buy, keep in mind that professional camera stores are more expensive than mail-order shops or online retailers. You're paying for convenience, personal treatment, the opportunity to try

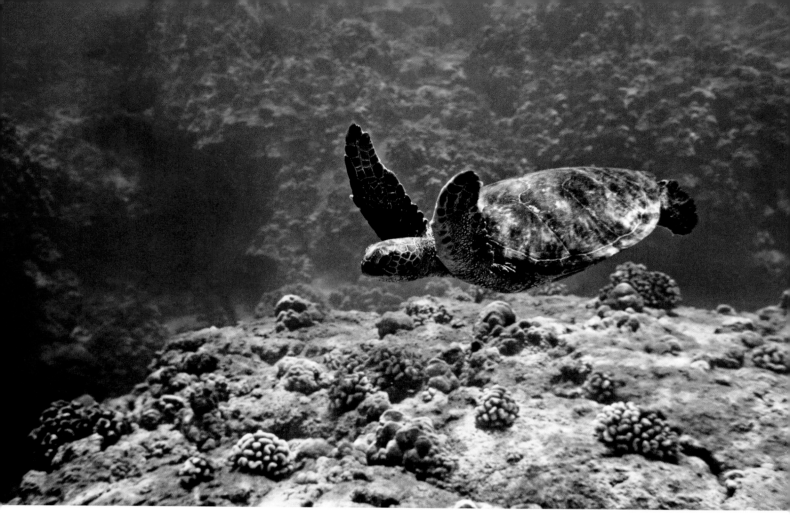

several options, salespeople that know how to use photo equipment, and an easy place to return something that doesn't work right. Those are all significant advantages—and you may decide it's worth spending a bit more to get them. If money is tight, as it often is at the start of a new business, there are a few very good mail-order and online equipment places—several of which are mentioned in the resources section of this book (see page 102)—that will treat you with some degree of respect. You should consider all the options, as most professionals do, and spread your business around until you're happy with a specific supplier.

Managing Expenses. To be in the photography business, you'll have to make a significant investment in equipment, computers, office equipment, marketing, and general business expenses. Fortunately, there are several options for the photo equipment part.

If you've got lots of money stashed away, pay cash for the basic package. Cash always ensures the best prices for the best equipment. Alternately, there's the age-old tradition of borrowing money; banks, credit unions, family, and friends are often the source of money to start up a new business. If you decide to borrow money, make sure you know what's expected from you in the deal—and what happens if you are unable to make the proper payments.

Some freelance specialties, such as underwater photography, require very specialized gear. This giant turtle was photographed in Captain Cook Bay (Big Island, Hawaii) with a Nikon Nikonos film camera, a 20mm underwater lens, and natural light.

Another easy option for photographers on a budget is the "rent-as-you-go" system. You can lease, or lease to own, from many professional photo and computer stores. This costs a little more on a day-by-day basis, but eliminates the need to come up with a wad of cash to buy expensive equipment. The costs are tax deductible, if you're in business, and the equipment is usually the very latest available. More than one successful freelancer has started out this way.

Insurance and Security. No matter how or where you get your gear, invest in an alarm system for your home or office. Get something good—something that will scare away would-be "borrowers" of your equipment long before they get their hands on it. Keep everything in sturdy, locked cabinets or build a secure storage area for your camera equipment. Never leave anything in your car.

Even with good security, insurance is an essential investment. Professional Photographers of America has excellent insurance that they offer to members; the insurance alone is worth the membership fee.

Equipment Knowledge and Testing. There's no worse feeling than having trouble operating a camera during a photography shooting session, especially on a trip to a distant location. It shouldn't happen—and it won't happen if you test, practice, and get to know your new equipment before heading to that important shooting session. Operating your equipment—every piece of it—should be second nature, so that you can concentrate on creating the images.

Computers

Computers are as important to photography, and the business of photography, as the cameras that create images. They're used to store, manage, sell, distribute, manipulate, and even create images. The sooner you become computer literate, the better.

What You Can Do. Even if you only keep an active client contact list and current checkbook, write correspondence, and create proposals on your computer, the machine will replace at least one full-time employee. If you're at all computer savvy, you can take it well beyond that. Today's computers are communication centers, research bases, graphic managers, and marketing tools. You can send letters and photos over e-mail; tweak and manipulate good images into great works of art; research just about any subject (such as a shooting location or new camera system); advertise, sell, and promote your images and services; create digital portfolios; design marketing materials for print or the Internet; manage huge catalogs of images—and a lot more.

Buying Smart. Today, there is so much competition in the marketplace that a very good, name-brand computer system can be purchased for around $1000. This would have cost as much as twenty times more just ten years

> **Computers are as important to photography as the cameras that create images.**

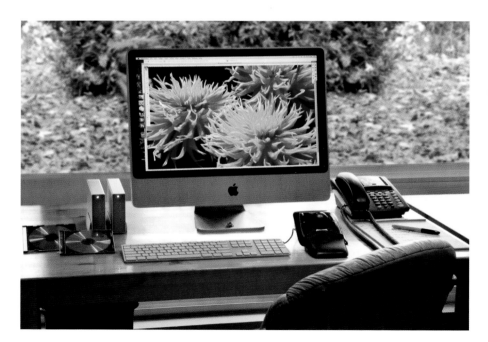

Work station for downloading images, then correcting and manipulating photos. Note the very large computer screen, external hard drives, and sensitive track-ball mouse.

ago. Still, this is definitely an area where you want to spend some time getting to know what's what before making a purchase. See what your colleagues in photography are actually using, not what a fast-talking salesperson says is perfect for your work. There are also lots of online forums and review sites for researching computer systems. (We use a desktop Apple Mac, which has a very big screen, fast processor, lots of memory, and plenty of storage.)

You'll need to have a computer that does a lot of things fairly well, and fairly fast—in the office, on the Internet, to handle image management, and for storage of everything. Everything. Naturally, the faster and smarter a computer is, and the more storage it has, the more expensive it will be. There's good news in this area, though: the major name-brand computer companies offer moderate systems that can be expanded as you learn and grow. This can minimize your initial investment and allow you to customize the system as your needs become apparent.

You'll need to have a computer that does a lot of things fairly well, and fairly fast . . .

Your camera and computer systems will be your fundamental equipment purchases when beginning your business. Learn to work proficiently with both before branching out into more exotic and expensive equipment. Let the hot-shot pros test the latest stuff and take the opportunity to learn from their exploration into new and expensive items. If you check out the forums, review sites, and photo conferences, you'll quickly learn what products can actually expand your abilities—and which expensive features/gadgets you should avoid spending your hard-earned money on.

Consider a Laptop. Portable laptop computers are great if you're on the move and want to have everything close at hand—or if you want to shoot tethered, moving your images directly to a laptop from a digital camera for instant review. A word of caution here: don't put everything—your financial

information, mailing lists, stored images, etc.—on the laptop that you take everywhere. If you and your computer are ever parted, you'll lose everything. If it's stolen, you may have identity-theft problems, as well.

Education. Becoming computer literate requires a little knowledge of a keyboard, some experienced help getting started, and some time getting up to speed with different software programs. Start by taking one of the many short introduction courses at business stores, community colleges, and business schools before buying a single piece of hardware. After that, move on to advanced courses related to your own business and photography needs. Computer and software manufacturers offer some very good courses on their products.

Portable image-storage and viewing unit that is also capable of sending and receiving images/text via the Internet.

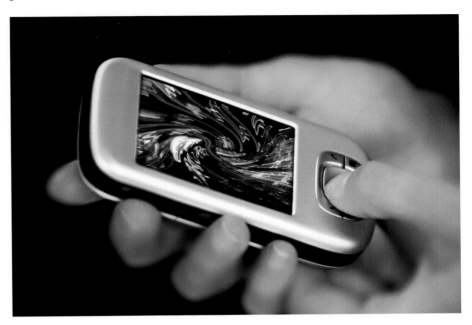

Software

Software is the heart of digital freelance photography. Or maybe we should say it is the brains of nearly everything you will ever do as a freelance digital photographer. Software runs your camera and lenses, your computer, probably your car—and it should run your business, too. Of course, you'll be telling the software what to do and maintaining some control, but the software will do what you ask—and it will do it quickly and accurately every time you ask.

The software that runs your camera, car, and computer is already up and running when you buy those items. You just push the button, or turn the key, and pay attention to what the screen says. We recommend a few additional programs that do not generally come installed on a computer. Most of these are also covered in more detail in the resources section (see page 102).

First, you'll need an office-management package—one that does word processing, finances, general administration, presentations, and online communications. We use Microsoft Office to complete most of these functions.

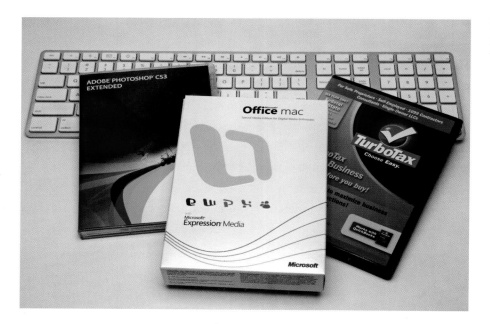

Basic freelance photography software: Adobe Photoshop, Microsoft Office, and TurboTax.

Second, you'll want a bookkeeping and tax-filing package. This should do your record keeping, write checks, produce financial statements, and tie into a tax-computation and tax-filing program. We use QuickBooks and TurboTax.

Third, you will need to invest in an image-editing program. This will allow you to do any needed image manipulation, correction, and retouching. We use Adobe Photoshop. A nice addition to this is an image management program that allows you to review all of the images from a session, make some general corrections, and send the "tweaked" images to a save file or on to a more sophisticated image-editing program.

There are literally thousands of programs available to assist with your digital photography, both on the creative and the business ends of things. Most of these should be considered only after you have mastered the basic ones mentioned above. Check out the photo software forums and review web sites to see what's available as you advance in shooting and business.

There are several ways to learn how cameras, computers, and other digital equipment work.

Education and Experience

There are several ways to learn how cameras, computers, and other digital equipment work. Given enough time and money, trial and error is one of the best. Once you've made all the possible mistakes that photography can throw at a freelancer, you will be one of the best professionals around. However, most people won't live long enough to make all the mistakes themselves. It's so much easier, faster, and cheaper to learn from the mistakes of others. That's called education.

Universities, community colleges, professional organizations, commercial manufacturers, camera clubs, and established professionals are great sources of education. Search the web for programs offered in your specialty from

these resources. Start with something small, say a seminar given by a local photographer or software company. Practice what you learn and master those techniques before advancing to more difficult courses. Do enough of this and you'll soon be teaching courses and giving seminars yourself. You'll also be shooting and computing like a professional freelancer.

Every issue of *PDN (Photo District News)* lists some excellent schools, seminars, workshops, and books that will help the freelancer learn and improve their craft. Few other professions offer the hands-on atmosphere that leading professionals, equipment manufacturers, and marketing organizations make available to photographers. After gaining a fundamental knowledge of the creative and business side of photography, attending one or two of these programs a year will keep you current on the industry and keep the creative juices flowing.

A night scene in Cathedral Square, Oaxaca, Mexico. Made with a tripod and a one-second exposure (approximately thirty minutes after sunset) to capture motion as swirls of color.

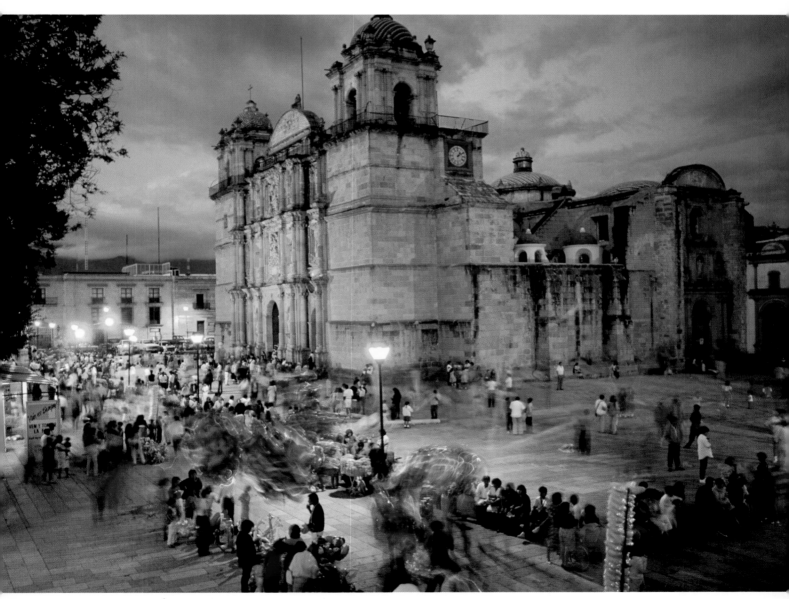

4. Creating Photos That Sell

Above all else, a freelance digital photographer is in business to create and sell high-quality photographs. In order to succeed for any length of time, you must have the creative and technical ability to make those images. No matter how smart a businessperson you are—or how great a salesperson—in the end, clients want good photos.

Show Only Your Best Work

Successful professionals all share a secret in making great images: they show only their best shots and toss the rest. Delivering creative images that wow your clients is as much a product of editing as it is shooting, so your ability to pick the best images from a shoot, or an existing library selection, is criti-

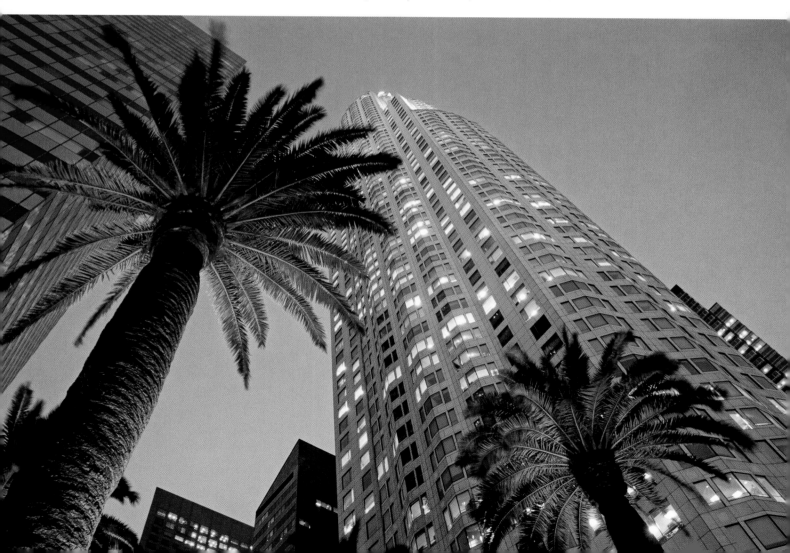

Downtown Los Angeles, California. Made at dusk with a 28mm angle-adjustable lens, tripod, and a five-second exposure.

Fancy dancer at a Yakima, Washington Indian powwow. Made with a 20mm wide-angle lens and a low camera angle to eliminate background distractions.

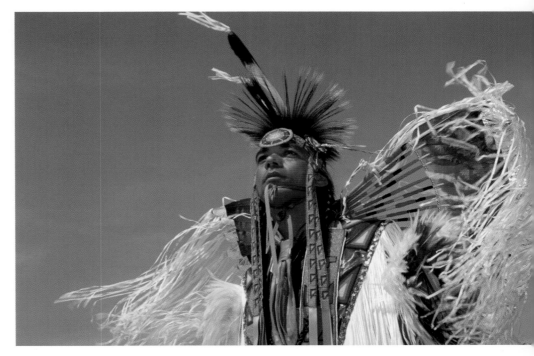

cal. If an image is obviously bad—due to poor lighting, composition, planning, or any other factor—look at it, learn from it, then toss it in the trash. Do not keep poor-quality images in your files. Even more importantly, *never show one to a client or prospective client.*

In order to be a good editor you must look objectively at the images from a shoot—as an editor, not a photographer. Don't think about how long it took to create an image, how hard the shooting process was, how expensive the equipment or talent fees were, or about anything except the final quality of the image. In the end, the images must stand on their own.

When editing the results from a session, start by taking a brief overall look at everything. We suggest using image-management program like Adobe Bridge, which comes with Photoshop. This will allow you to examine several hundred images from a single shoot, keeping the best and eliminating the obviously bad ones. Toss everything that's obviously bad—images with improper exposure, poor focus, and/or unappealing composition. You'll quickly recognize the really good shots when doing this edit, so flag anything that really jumps right off the computer screen. These are the successful images that will make your career as a photographer.

When editing the results from a session, start by taking a brief overall look at everything.

This editing process may sound simple—and in reality it is—but it takes time and practice to refine your eye and your editing skills. Most photographers find it difficult to trash an image, no matter how bad it may look. If you can't toss the bad ones, then file them in a separate folder and leave them there until you get over this "no toss" mentality.

Of course, among the "not perfect" images, there may also be some images that are still keepers—images that just need to be fixed up a bit in order

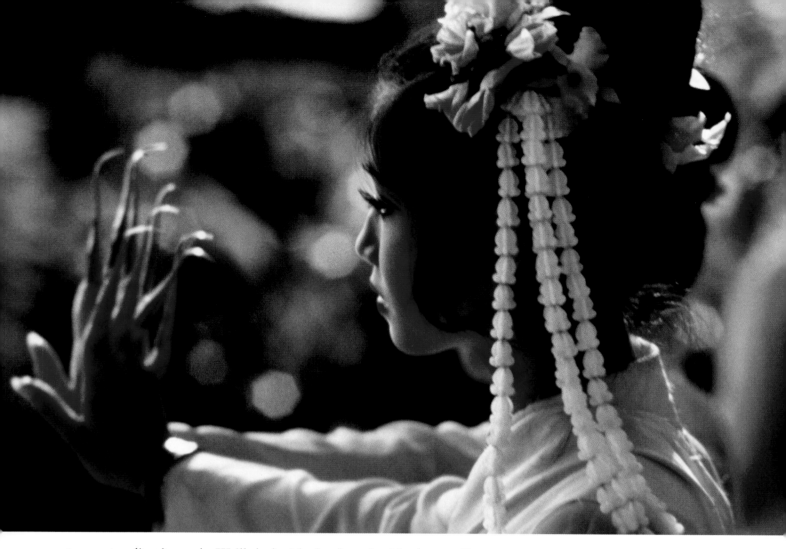

to meet a client's needs. We'll deal with that later in this chapter. For now, though, let's start by examining the qualities that our final images should have.

Classical dancer in Bangkok, Thailand. Made with natural light and a 300mm lens to blur the background.

A Good Photographic Image *vs.* A Great Photographic Image

A Good Image. The majority of people who purchase and use your images want something that will meet their own expectations of creativity, quality, and content. They may or may not be interested in your expectations, which may or may not be more demanding. Mostly, this means producing a image that meets their business needs, not any creative standard. Those needs start with showing their product/subject in the best possible manner, so they can sell or promote it to their own customers.

Professionally speaking, clients also consider it important that contracted and/or purchased images are produced on time and at the promised price. They expect images to be well-presented, clean, clear, well-exposed, and sharp. "Wow, that's a great photo—it's going to sell lots of my products!" are the best words of praise you will ever receive from a client. It almost always means they will be a good source of word-of-mouth recommendations.

No matter how creative, leading-edge, advanced, cool, or exciting an idea you offer may be, the client will always judge it based on their needs, not yours. We've said this in two different ways because it's so important. This is the basic dynamic that should be foremost in your mind when planning, creating, and delivering the images.

What all of this means is that you have two creative things to accomplish in creating a freelance image for sale. First, you have to produce images that jump off the computer screen or printed proof page; second, you have to produce images that meet the needs of the client. That's what defines your creative ability. The more exciting your images are in selling a client's products, the more excited your client will be about working with you as a freelancer.

When planning a shoot, or selling images, remember that client-pleasing images are more a product of your ears than of your eyes. Listen to your client. They will tell you exactly what they expect you to produce. Create the images they ask for, not what you imagine they want to see. It's a simple process. When shooting a project, you can expand the scope of coverage and creativity to offer the client additional looks at a given subject—but only *after* you've produced exactly what they've requested.

A Great Image. The difference between a good image and a great image is also the difference between an adequate photographer and a great one. Exciting images with impact are usually followed by sales to clients, which is the test that determines greatness.

The best images are created by being in the right place at the right time, with everything set for the shoot, and having the technical ability to create the image. Rarely do great images come to photographers who wander around with no plan for what they're going to shoot, no idea what's about to happen, and little technical ability to use in capturing the images.

A seasoned freelancer always knows when things are coming together in a shooting situation. The light is right, the mood is right, and the subject looks as good as is possible. With all these things in place, the shooting and results are up to your capabilities. This is the time to move around the subject looking, shooting, and visualizing the final images. Back off, get close, change the light, change the lenses, change your attitude. Don't settle for adequate; look for something that will be outstanding. This is the shooting life of a successful freelance photographer.

A seasoned freelancer always knows when things are coming together in a shooting situation.

A Good Digital Image *vs.* A Great Digital Image

A Good Image. The digital age has added several interesting features to the world of photography. No longer are freelancers simply creating a photograph that reflects a situation, product, or location. Now, clients know what can be done to an image in Photoshop. You need to understand this knowledge and expectation going into every photographic situation.

A good *digital image* is one that has been "corrected" to meet the client's needs beyond what we described earlier as a good *photograph*. Today, you are expected to create a "perfect" photograph—and, of course, you have to do just that.

Most of your digital photography, for example, will need some cleanup. This usually means eliminating small spots caused by dust on the camera's image sensor or the rear element of your lens. No matter how diligent you are about keeping things clean, there will be spots. This is normal, and you can quickly clean up these imperfections using a program like Photoshop.

Some of your digital photography will need color correction and/or contrast changes. Frequently, cropping will be required; what the image sensor records isn't always precisely in sync with what you saw in the viewfinder (or in your mind's eye, for that matter). These are quick and easy things to adjust in an image-editing program and can help ensure that your images look as good as what your eye saw in the original scene.

Frequently, a client watching you shoot their product/location will ask you to remove some element or to add something that was not part of the original scene. This may mean removing a telephone pole and power lines, or eliminating someone from a beach they want to look empty. It can also mean changing the color of a car, suit of clothes, and/or a person's hair.

Beyond these basics, any further manipulations should probably be done by a designer or the client's advertising agency. The client knows your soft-

Stock photography of a coffee sign at Seattle, Washington's Public Market. Made with a tripod and two-second exposure just after sunset.

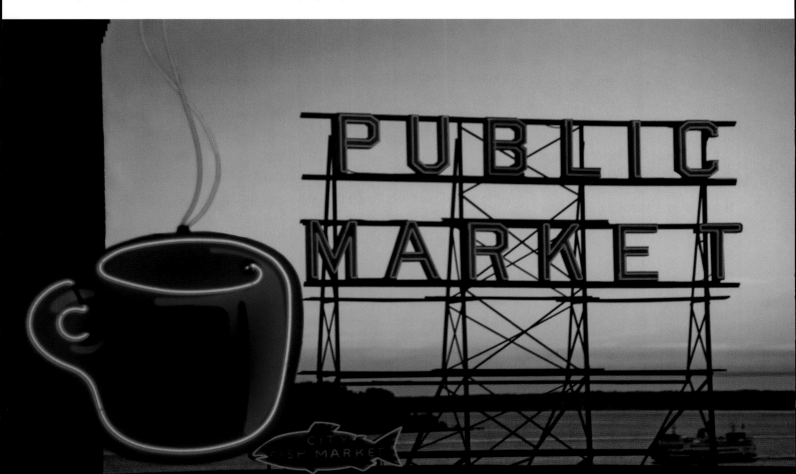

ware is called *Photo*shop, not *Designer*shop, so they expect you to make things right. Then, let their art designers manipulate the images. The ethics of all this manipulation are covered later (see pages 88 to 89).

A Great Image. Creating great digital images requires an additional step beyond those just described in the previous section. It requires you to slip into the digital mindset when shooting. This means considering, right from the start, what creative possibilities will be available when you download the images and open them in Photoshop.

The ability to tweak an image in Photoshop can help change a good image into a great image.

The ability to tweak an image in Photoshop can help change a good image into a great image. This may involve changes as subtle as adding a highlight in just the right place, improving the color saturation, or sharpening/blurring image elements. In some cases, it will be as drastic as manipulating the elements themselves. This may mean moving something, eliminating something, multiplying something, or creating a whole new element from another photo.

All of this custom digital work can be a lot of fun—after all, putting a cat's head on your sister's body or a third eye on your brother's forehead is good for a laugh. More usefully, the program allows you to place people where they weren't, change eye and hair color, make a beach look long and palm-lined, give a woman a better shape, put muscles on a man, make food look tastier, and so on. The options are limited only by your imagination. For more on this topic, please see "The Photographer as a Digital Artist" (page 56) and "Avoid Misleading Digital Manipulations" (page 88).

Creativity

Creativity is what enables you to make an exciting photograph of a tennis shoe, a parking lot, a gas station, a gravel pit, and other day-to-day subjects. Sometimes you have to make a less-than-attractive person look like a million bucks. On other shoots, you'll need to make a living room look a little larger. A creative photographer can do this, creating an uncommon image of even the most common subject. That's what your client expects from you, and that's what you should expect of yourself.

You don't a get day off, however, when your assignment features beautiful places or people. It's easy to make a Maui beach look good at sunset—especially if you have an attractive couple and palm tree to frame the scene. The same goes for shooting beautiful models in the latest miniskirts, a great plate of food in a beautiful restaurant, and so on. Most people think all you need to do is show up and shoot (that's why everyone likes to shoot beautiful subjects), but the clients for these special subjects still expect the images you create to look *even better* than the originals—just like the clients who hire you to photograph tennis shoes and gas stations.

You must develop an eye for seeing what can be done to make a scene or subject look as good as possible. This requires practice and looking at the

world's best images of the subjects you shoot on a regular basis. You need to develop the ability to create a photograph that is more interesting than the original scene. Over time, the way in which you implement your creative ability will become your unique style.

Your Style

Your style of photography is reflected in how you deal with subjects—it's how you see a scene or subject through the camera, place the lighting, and make the final images. Your photographic style may be what prompted you to become a freelancer in the first place.

To a great degree, your style will determine how successful you will be. Throughout your career as a freelance photographer, your style will also be your primary sales tool. It is the basis of your reputation. Developing your style is a neverending and always-changing process—as is your creative ability to photograph a subject. It is part of every image you create and every assignment you complete. It is your style that puts you into a separate class. It's who you are as an artist.

You are the force that's responsible for developing a photographic style. It should be the result of studying the styles of many other successful photographers, artists, and designers, which you can do through pictorial books, bet-

Swimsuit model alongside a pool at the Mauna Lani Bay Resort on the Big Island of Hawaii. Made with natural late afternoon light and a gold reflector.

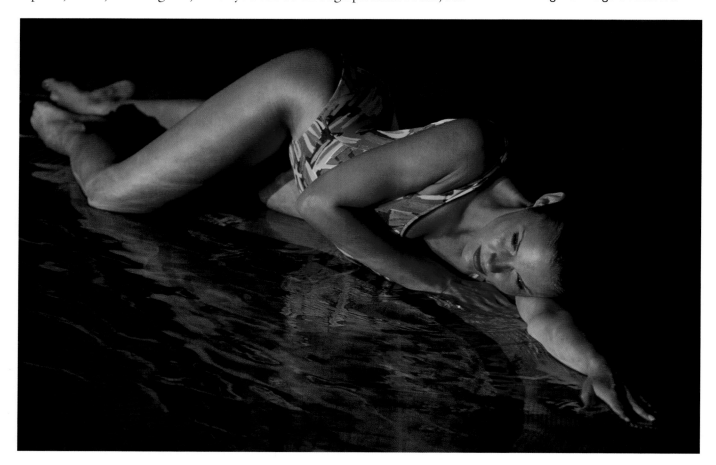

ter magazines, and gallery showings. After trying several of the styles seen in these resources, you'll see what works for your own eye and begin to improve upon the results. A style isn't developed overnight, it's a combination of who you are, how you see, and how those factors come together in your photographic images. As you grow and change over a lifetime, so will your style.

Great Ideas

A former *National Geographic* photo editor once said they were neck deep in talented photographers but only ankle deep in good ideas. As a result, those photographers who consistently had the best ideas got the best assignments and staff positions. When you see a photographer's name in *National Geographic*, rest assured they are among the very best. You can join those ranks, too; it's simply a matter of having good ideas.

Freelance photographers have the best of both photography worlds. They get to shoot just about any subject they want, then sell the images they create as stock photography; conversely, they get to shoot assignments for clients who establish the subjects that are photographed. No matter what the subject you photograph, or who gets to choose it, the quality and creativity of the image may well be determined by the ideas you bring to the creating process. When photographing anything but earth-shaking news events, the ability to create a great image of a common subject is valuable.

They were neck deep in talented photographers but only ankle deep in good ideas.

Best-selling images, whether freelance or assigned, generally portray a mood, feeling, or concept, rather than just a subject. Things like happiness, sadness, success, failure, confidence, and fear are such concepts. It's easy to shoot a beautiful face, but it's more difficult to have that face show genuine emotion and capture that feeling with a camera. If you can do it, your clients will see and appreciate the difference in the final image—and so will your bank account.

When you create good photos, they come from your good ideas—which almost always come from something you've seen. That's why we suggest that you keep an idea file of concepts, potential designs, and subjects that interest you—anything that has potential for future photo sessions.

A good idea file comes from reviewing the best photography in your special areas of interest. Do this whenever you have a little extra time. You will find the best photography by reviewing the web sites of the best photographers in the world—many of whom are mentioned under the various specialties in chapter 2. Magazines and books are also excellent places to see good work.

Print out copies of images that you think are good and that inspire you with ideas for future shooting. These clips, as we've suggested, will help when planning shooting sessions. Look for ways to improve on the shots in your idea file—ways to go beyond the basic idea and enhance your own results.

(*Note:* To be clear, these printouts should serve as references only. They are beginnings, ideas, and stimulation to get out there and learn something. You should not copy them. Copying does nothing to improve your own work and may have legal consequences.)

When time and money permit, plan a self-assignment based on an idea from your idea file. Set out with no other goal than creating an exciting image of something that catches your interest. Share your plans with people who have an interest in the subject, situation, or idea—even clients—so they may offer suggestions and support. Images made from such sessions will often become part of your portfolio and can even become strong sellers in your stock photography library.

The Photographer as a Digital Artist

The digital world opens up a whole new set of creative opportunities for the photographer as an artist. Most photographers who are competent users of image-editing programs almost can't help but become digital artists now and then.

Creating digital art from a normal photograph is easy when using Photoshop. There are thousands of options from which to choose, each offering a final photographic image that can be truly unique. Take a few minutes away from this book to create an artistic digital photograph. Select a photo, such as an airplane in flight, and open it in Photoshop. (*Note:* Before experimenting, we suggest making a copy of the original image.) Then, click on the Filters menu. You'll see several categories of filters from which to choose, each

The original image (small) shows a Boeing 747 jumbo jet just before landing. Using digital manipulation with Adobe Photoshop, the shot was turned into an art image (large).

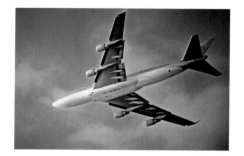

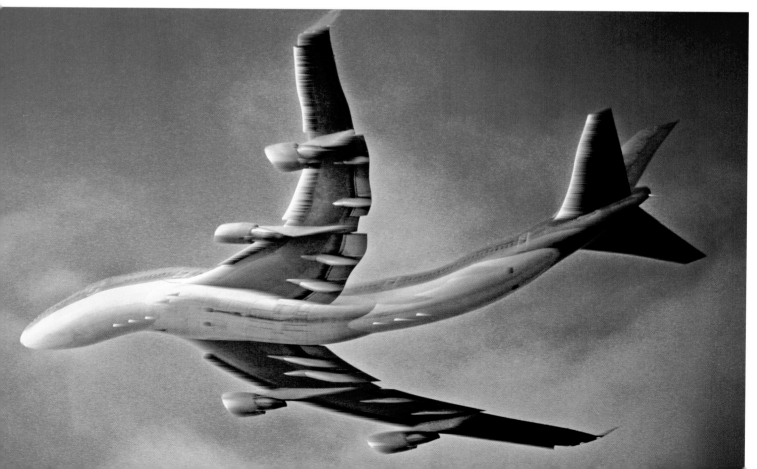

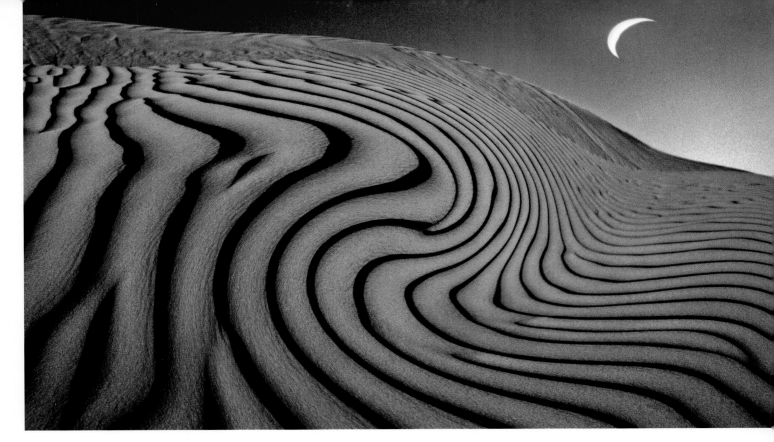

This image of the Sahara Desert in Tunisia was digitally manipulated using a basic twisting filter in Adobe Photoshop. The quarter moon, from a separate image made at the same time, was inserted after initial manipulation.

with several options. Try anything that catches your interest and see how easy it is to create a digital masterpiece. In our case (facing page), we've selected the Distort category, and under that the Spherize filter. The result is a slightly twisted jet. You can repeat the same process over and over again for even more distortion each time. If you don't like the results, simply reverse it by going to Edit>Undo (or close the file without saving).

Filters are just the start of the possibilities. There are accomplished Photoshop artists who can create complete images just using the software. Others seamlessly blend dozens of images to make a final composite photograph. Whatever your interests, this is an intriguing and potentially profitable use of the digital medium.

As a freelancer, when you create an exceptionally interesting and unusual piece of digital photographic art you should also be considering the potential sales opportunities. If you print only one of these images, it's an original. If you create and sign a specific number of prints, you have a limited edition. Such limited editions have been very profitable for fine-art photographers all over the world.

Modern desktop printers are of such high quality that creating good limited editions is within the reach of most photographers. Create a dozen different limited editions and put them on a web site for sale. Carry a portfolio of these editions to furniture stores, interior designer's offices, and ad designers. Your limited editions could become an unlimited source of creative income.

FACING PAGE—Images of an Arabic veiled woman and silhouetted camels (Sharjah, United Arab Emirates) were combined digitally.

Managing Your Image Files

Digital photography offers a lot of opportunities to create beautiful images—and if you're like most creative people, you will create a lot of images when photographing those opportunities. A *lot* of images. If you're interested in selling those images, you're going to need to manage and archive your files effectively. If you can't find the shot a client wants, you might as well not have the image at all.

Shooting digital photography starts with a few hundred images of a subject or two. It grows into a few thousand images of a handful of subjects. Pretty soon, your computer's hard drive is full of images—scattered all over the place in files you don't recognize and often can't find. That's early in your career. From there, it will get completely crazy if you don't have a system and a plan. Don't wait until your hard drive has 100,000 images on it to start sorting and filing them into a library.

Managing images is the single most important daily task of a freelance photography business. It's as important as making the images in the first place. (Okay, we're exaggerating; it's probably more important to pay your taxes and remember your spouse's birthday—but image management is right up there.) Start with the images you made today and immediately identify every image with a unique name, identification code, and number. There are several programs on the market that are designed to help you accomplish this task as you examine and edit a shoot.

We begin by reviewing the entire shoot in Adobe Bridge, which comes with Photoshop.

We begin by reviewing the entire shoot in Adobe Bridge, which comes with Photoshop. In Bridge, we examine every picture and grade them in order of quality and importance, assigning one to five stars for each image. Then, we make an identification and send the image file to a separate folder we've created for each subject in the shoot. After this is completed, open each of these separate folders in Bridge and began the process of closer examination, color correction, retouching, and expanding the caption information. We also add a copyright sign with our name in the caption (also called a metadata file). This file stays with the image forever. (*Note:* We dump every poor-quality, unusable, or undesirable image into the trash immediately. You won't have room in your files to save these. Worse yet, sooner or later a client will see a bad photo. Additionally, a bad photo can distract you from working with the best images.)

We suggest shooting images in your camera's RAW mode and creating as large an image file as possible. If you have a 12 megapixel camera, do not shoot in its 6- or 3-megapixel setting. It's possible to increase the size of an image after it's shot, but it usually looks bad. Reducing the size of a larger image always looks better.

We save every final "corrected" image in as large a TIFF or JPEG document as possible, leaving the RAW camera document in the same file folder,

as well. Working on large files is easier and the results will be sharper when the files are reduced for prints, brochures, and related materials.

Saving the RAW image will be useful for several reasons. Some editorial publications want to see the RAW image to ensure that it hasn't been manipulated from the original scene (this is especially important in hard news photojournalism). Also, many agencies, publishers, and clients want to do their own corrections and manipulations from the RAW images.

We maintain separate standalone hard drives, usually 250GB in size, for every travel destination in which we specialize. This allows us to keep our computer storage space open for working on current shooting projects. For example, we have hard drives for places like Hawaii, Mexico, Italy, England, and so on. On each of these hard drives, we have separate files for each city, region, and subject of the destination. This makes it quick and easy to find a photo of a specific vineyard in the Chianti region of Tuscany, Italy—and this sort of efficiency usually means a sale. In fact, simply maintaining a large library of stock images can yield a good income.

TOP—External hard drives are each suitable for holding a huge volume of very large image documents.

BOTTOM—DVDs and CDs stored in a custom file cabinet. Discs are an excellent way to provide clients with working images and proof sheets.

We also make a backup copy of every hard drive and keep it in a separate location. This may sound a little excessive, and more than a little expensive, but it isn't. Having a data-reclamation company retrieve 5000 of your best images from a hard drive that's crashed can cost two or three thousand dollars—and that's if the damage is not serious. If the damage is bad, you'll flat-out lose everything that was on the hard drive. Backup hard drives, in contrast, are usually less than a hundred dollars. You can accomplish the same level of security with DVD copies, if having extra hard drives is too much trouble or too expensive.

5. The Business of Business

Business is business. Whether you are a freelance photographer or a shoe-store owner, you are offering a product and/or service for sale. In this respect, photography is no different than any other small business. That's how the people in banks feel when you need a loan; that's how the Internal Revenue Service feels when you file taxes; that's how your city and state feel when it comes to business licenses; and that's how the buyers of your photography feel when you ask for their payment. In order to be a successful freelancer, you have to acknowledge this and treat your photography business as a *business*, not a creative art.

A Hobby *vs.* A Profession

Many photography enthusiasts make some nice extra income shooting and selling photography to their family and friends. To a certain point, this is considered a hobby. If, however, you accept more than a few dollars to make images and sell them on a frequent basis, you are in business. This is the position the IRS takes in most audits—even if you have a regular day job.

If you're reading this book, you may have advanced to the stage of selling enough photography to establish a business, or you may be considering photography as a profession. If this is the case, you should go through the process of establishing a small business. This means acquiring the proper licenses, tax identification, and so on. To keep things simple at first, you might consider establishing a sole proprietor business, in which your business taxes are included with your personal returns. Seeking the advice of a CPA (certified public accountant) is a good idea when making this decision. Keep in mind that—even with a business officially established—you can't deduct thousands of dollars for equipment, materials, and photo vacations, if there is little or no income and you are also employed in another business.

> **You should go through the process of establishing a small business.**

Starting a Business

There are many things that must be done before and during the startup of a new freelance photography business. Take the time to find out exactly what you need before accepting a client's money or projects. In order to prevent a lot of problems, you should start by obtaining the licenses required by your

state and city. This may mean applying for a tax identification number, posting some sort of a bond, and showing proof of certain types of insurance. Learning what's required entails a simple call to your city's business office.

Even before you apply for a business license, it's a good idea to have a basic plan that outlines what you hope and need to accomplish in business. This doesn't need to be complicated—a simple list of your capabilities, resources, markets, and financial aspirations will do in the beginning.

Successful businesspeople have the ability to administrate and control how their business operates, in addition to providing the products and services offered to clients. Once you get started in business, things will take on a life of their own. Don't worry if the goals and needs of your business change. Outside influences, such as clients, the Internal Revenue Service, financial institutions, governments, and family, will all contribute to the way things work in your business.

Successful businesspeople have the ability to control how their business operates.

Basic Business Planning

There are several basic things you need to consider in developing a new business plan:

- **Your company format.** Will it be a corporation, sole proprietorship, partnership, or limited liability company? Consult a lawyer and a CPA before taking the steps to establish a business format.
- **Your business name.** Is the name you want being used by any other business in your state? Have several choices in mind. Do a web search and talk with your lawyer. Keep it simple, perhaps using your name in the title.
- **Your business goals.** Create a list. This may include establishing a studio, an office, a stock library, or a location-shooting business.
- **Your costs.** How much will it cost to start and stay in business for a few months?
- **Your services.** What specialty photo services or products will you offer? See chapter 2 for examples. Is there a need for this field in your area?
- **Your angle.** What makes your talent and business unique?
- **Your equipment.** What photographic and business equipment will you need? Make a list and research how much will it cost to buy everything.
- **Your supplies.** What other materials and inventory will you need? Brochures, checks, stationery, signs, and so on must all be planned for (and paid for). Make a list.

- **Your forms.** What business and photo forms do you need? You'll likely want business cards, image-delivery memos, invoices, project-bidding forms, model releases, and so on.
- **Your operational budget.** How will you sell your photography? How much will it cost to sell your images? Draw up a working budget.
- **Your market.** Who will purchase your photography? Outline your potential markets. Compare your business to similar businesses in your area and specialty.
- **Your overall financing.** How will you pay for everything? List a year's working budget, including startup costs, general operations, equipment, sales, and contingencies. Expand this budget into three years of operation with the addition of expected profits. The three-year figure would be a good place to start a freelance business.
- **Your legal requirements.** What are the legal requirements for starting and operating a business in your area? You may need a business license, tax permits, professional bonds, liability insurance, a federal identification number, and so on. Don't start selling your services and products without completing the proper legal requirements. Your CPA, lawyer, and SBA (Small Business Administration) advisors will be able to help in this area.

Professional Help

Ask for help starting your new business—professional help. Unless you're a lawyer, CPA, and a successful independent businessperson, you will need the help these kinds of professionals can provide. It's a lot faster, easier, and less expensive to learn from others than it is to make all the mistakes yourself.

The resources you should consider when starting (and operating) a business include accountants, lawyers, business consultants, sales agents, bankers, printers, and experienced family and friends. If you already know someone running a small business, see if they will share a few words of advice over lunch—you get to buy. This person might also be able to recommend a CPA and lawyer who handle small and independent businesses.

Check out the Small Business Administration's (SBA) web site (www.sba.gov). This is an excellent place to find information about startup business forms, and perhaps an experienced counselor. Most city and state governments have a Department of Revenue or a business-development office that can also provide basic business information.

When it comes to tax and licenses, and almost any startup business forms, take the time to talk with a CPA. They will know the legal requirements that

Ask for help starting your new business—professional help.

must be met and the records that must be held. Records should be kept from the very first sheet of paper establishing your new business.

Most of the professional photography associations also offer seminars, workshops, and books specifically aimed at starting and operating a photo business. *Photo District News (PDN)* offers several conferences each year, in which some of the leading professionals offer their advice and recommendations. Many professional photographers, in all of the various specialties, also offer workshops for beginning to advanced photographers. This is an easy way to find out what's really happening before you start spending money establishing a business.

An even more productive way to learn about the business of running a business is at a community college. Taking basic classes in accounting, business administration, marketing, and management will go a very long way toward making you a successful businessperson. You might also consider a basic journalism class at the same time. Most community colleges have continuing-education classes taught by successful people. These are often available in the evening—and the small amount of money and time you expend on this training will save you a lot in the long run.

Being a Professional

The people who buy freelance photography are businesspeople, and they will expect a certain amount of professionalism from you. No matter how creative you are, or what your chosen field in photography might be, it's a business. Try to look and act like a business professional at all times.

To do this, you'll need a business name, an official address, a business telephone number and e-mail address, as well as a web site. Answer all of your information requests, phone calls, and correspondence like a professional. Don't let your children, spouse, or sweetheart answer the phone, unless they do so in a businesslike manner. Simply saying "hello" is not enough—and having your dog barking or child screaming in the background does not contribute to the professionalism of a sales call. Keep things businesslike and you'll inspire much more confidence in your prospective clients.

The very best advice we can give is to look and act just like the clients you want to buy your images. That may require some advance research, but it will be worth the effort. The same goes for talking with bankers and auditors; try to look a little better than they expect.

Keep things businesslike and you'll inspire much more confidence in your prospective clients.

The Digital Business Office

A Physical Space. Richard Branson, the CEO and president of Virgin Airlines (and several other mega-businesses) doesn't have a regular office—or so he has said during interviews. People either have to find him or deal with lower-level officers in his business. Because his "lower level" people

Freelance author and travel photographer Cliff Hollenbeck's eclectic office.

have street addresses, we can assume that they also have offices. Likewise, until such time as you (like Branson) are the president of a huge conglomerate, you should assume that having an office is important to conducting your business.

Establish a working office, studio, or other work space early on in your business life—even if it's a back bedroom in your home. This is where you will go to administrate the business, keep the files, and handle the communications with clients and suppliers. Having an office establishes you as a working professional.

The field of photography in which you specialize will determine the type of office you need, as well as its location. Wedding, portrait, fashion, and commercial photographers generally require a working studio or large home office. (*Note:* In some cases, you can get away with a small home office, but this means you'll need to meet with your clients elsewhere [their home, place of business, etc.] and rent studio space when necessary.) Most location shooters (news, travel and the like) have offices in their homes. Some of these offices, as in the case of our travel business, can become as large and elaborate as a downtown place of business.

A location photographer's reception area. Note the variety of photo prints and published examples of work created by the photographer that are on display.

A makeup artist and hair stylist prepare the model for a studio fashion shoot.

Wherever and whatever your photo office is, make sure it looks like a place where business is conducted. Your office is a reflection of your work, so try to look like you're a successful and in-demand photographer.

Phone. In order to compete in the world of digital photography, you need to have the equipment necessary to compete in the world of digital business. At the very minimum, this means having a business telephone number, preferably on a smart cell phone. This way, you can always be available (or return messages when your phone is off in the restaurant or movie theater). You should be able to get e-mails and perhaps even do web searches on a good phone. Your phone isn't a toy to play music on—or the latest handheld do-

everything gadget on the market—it is how you communicate with existing and potential clients.

Computer(s). A modern business computer, with a compatible printer/scanner/copy machine is the next most important business equipment item you'll need. This is where you will write proposals, keep records, pay bills, and research anything associated with your business, clients, and locations. This computer may also be the place you manage and work on images from photo shoots. We have two separate computers. One is for business administration, and the other (which is not connected to the Internet) is for photography.

Furniture. A work desk and file cabinets are the final items of equipment you'll need. Although it's tempting to keep all your records on a computer,

This image scanning station includes two transparency/slide scanners, a light table, and external hard drives.

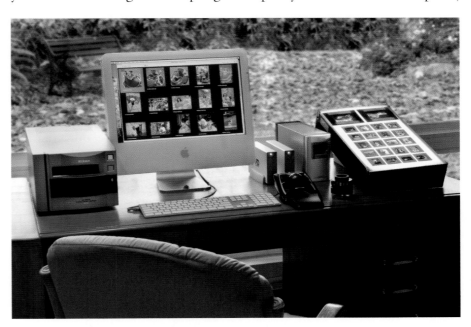

Office file cabinets filled with photo-shoot documents, research information, and related materials.

having hard copies in a regular filing cabinet may someday prove to be a life-saver. Computers often crash, destroying everything inside. File cabinets don't crash. You'll also want a secure place to keep legal paperwork, tax filings, insurance papers, personal papers, and similar important documents.

Business Software. Most freelance photographers like to keep their business small, doing most of the day-to-day tasks themselves. This includes things like keeping the checkbook, writing business letters, writing proposals, designing brochures, printing stationery on an as-needed basis, and managing client contact lists. These tasks can easily be done by a single businessperson using business software like Microsoft Office Suite and the Intuit QuickBooks and TurboTax programs.

Microsoft Office is a powerful suite of business-oriented programs including Word (word processing), Excel (a financial and data program), Power-Point (a visual presentation program), Messenger (an online communication program), Entourage (an extensive email program), and other tools for managing your calendar.

Intuit QuickBooks is ideal for record keeping, tracking expenses, printing checks, paying bills, creating estimates and invoices, tracking sales, creating forms, printing 1099s, and exporting your financial information to a tax-filing program. TurboTax, also from Intuit, blends nicely with QuickBooks and provides simple-to-use online filing of state and federal taxes for home and small businesses. It covers such important things as self-employment tax, small-business tax tips, and offers very good help with tax deductions.

These programs can be reviewed at the respective manufacturers' web sites, which can be found in the resources section of this book (see page 102).

Stationery and Forms. You'll also need a minimum amount of business letterhead, envelopes, address labels, and business cards. Have a simple logo designed that can be used on all your paperwork, establishing a professional look and brand identity for your business. You'll also need delivery memos, invoices, and project bidding forms, all of which can be printed on your letterhead.

Have a simple logo designed that can be used on all your paperwork . . .

Capitalization

It takes money to start and run a freelance photography business—money for office and photography equipment, money to pay rent, money to produce marketing materials, money to make sales calls, and money to live while you're doing all those other things. Eventually, the income and profit from your clients will pay for the initial costs—but you must have enough money to stay in business until that time.

The startup budget you've already produced (see page 63) should cover everything you need to operate for at least a year. Having enough money to last for three years—without any profit—would be a lot better.

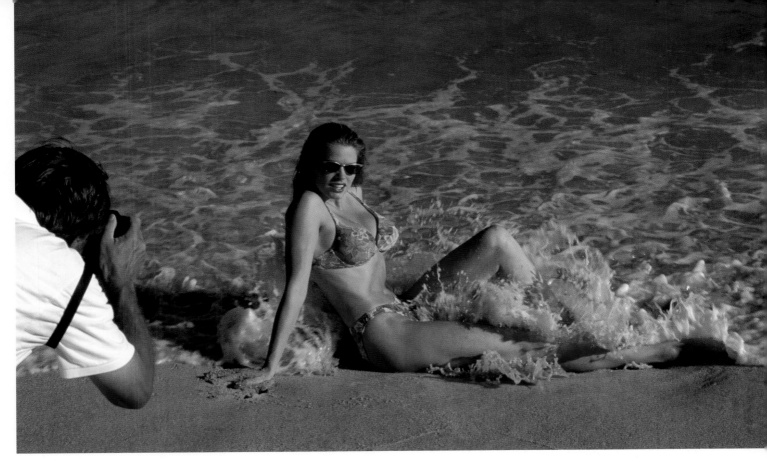

Catalog photographer shooting a swim-suit model at a beach location.

There are many ways independent businesspeople get enough capital to start and maintain their business for a year. Savings from a current job is one of the best ways to get money (next to a nice lotto win or a big family inheritance). If you don't have money from one of these sources, you'll probably need to take out a loan. If you must borrow money, always include a small contingency fund—just in case you need to make a few payments when business is slow. The places you'll have to go for a loan know, and appreciate, this important business requirement.

Loans are available from many places, all of which should be examined—banks, credit unions, from your day job, family, friends, and even grants to produce materials for a worthy cause. All of these sources will want to see your business plan, past credit history, and tax returns. Your CPA and other business advisors can be a lot of help with completing the financial paperwork that will be required.

If you need to cut corners and save a few bucks at the start of your business, consider purchasing used office equipment and leasing the more expensive components of your computer systems and photo equipment. You can also rent, on a by-the-job basis, anything that's too expensive to own at the beginning.

Instead of sinking your money into exotic lenses you'll rarely use, spend as much as you can on marketing and sales—that's what will bring in the jobs and income. You can always expand your lens collection as profits improve.

How Photography is Different

Despite our assertions at the start of this chapter, it should be noted that photography *is* a bit different than selling shoes—and, for freelancers, it does present some unusual, if not totally unique, requirements as a business.

The business of freelance photography really entails three different business functions taking place at the same time. These are:

1. Producing a creative product or service
2. Providing great customer service
3. Administrating a small business

At any given time you will be doing one, two, or all of these jobs, which may seem like juggling three running chainsaws. If you take your eye off even one aspect of the business, things can get out of hand quickly. As an independent businessperson you must accomplish each of these tasks in an equal, organized, and efficient manner in order to survive. It's not that hard to do, so long as you keep your eye on all three chainsaws at the same time.

Producing the Products. Obviously, the most important part of being a freelance photographer is making the images that are for sale. All of the other business tasks, even though equally important, come second. Constantly work toward improving the images you create. Take every assignment seriously, always looking for the best way to complete the task in the most creative manner possible. The better your creative work is—especially when it's backed up by competent business practices—the more clients will be knocking on your door.

Providing the Services. In order to be successful, you must deliver images on time, on budget, and in a manner that is satisfactory to your client. Do this with a smile, making sure your clients get more than they expect. This is called customer service; it's what separates the best from the rest in all businesses.

Most of your clients will consider the photography they use to be just a small part of their marketing and sales efforts. That's because it *is* a small part in the scope of their much larger and more expensive efforts to attract customers. Sometimes that means you won't receive the treatment, recognition, or appreciation an artist should be afforded. That's because they look at you as a service and a product.

Corporate photography of a Crystal Cruise ship anchored in the bay of Santorini, Greece. On-camera flash was used to light the statue in the foreground. A wide-angle lens kept both subjects in focus.

If you want to receive praise from a client, shoot good images and deliver them on time and at the price promised. Make your deliveries without any complaints about the weather, the models, the changes in schedule, the additional shots they requested, or the difficulties. Do this every time you shoot a job and the clients will think you are an artist and a genius.

Keep in mind, as well, that today's shooting assignments may be expected to be ready for viewing at the client's desk in the morning. That means you'll often need do the image selections, editing, corrections, and whatever else the client wants, in the hours between the end of the your shooting session and the beginning their morning sales meeting. This is called an "all nighter" in the business world.

We've shot assignments halfway around the world—in the jungles of southeast Asia where it was hot, humid, and a long way from civilization—for clients, back in their comfortable air-conditioned offices, who wanted to see the results a few hours after the shoot. And they wanted to see them every day. Thanks to digital technology, this kind of quick service is within the realm of possibilities.

We like to deliver a large number of images, from which our clients can make their selections, on small document proof pages. You can convert large RAW or TIFF files into small JPEGs with most digital image-editing programs. These smaller files can then easily be sent to a client over the Internet in e-mails. If you need to send larger image files, try using a file transfer (FTP) web site. This is a secure, fast, and simple system, once you've mastered the basic requirements.

Whenever supplying images to a client, keep in mind that your reputation as a photographer will be based on what your client sees, not what you shoot. While it's possible to send a whole day's images to a client halfway around the world, you should still edit the images first to eliminate the obvious bad stuff. Bad images have no useful value and will not impress your client. We suggest pulling out your best shots—the ones you know will meet the client's needs—making any needed minor corrections, and sending those. Naturally, you should save the rest of the acceptable images as a backup for potential use in the future.

Ultimately, you should keep your work simple. Shoot good stuff, make smart sales calls, and run the business like a business. If you are as creative in your services as in your shooting, your clients will love you—as an artist.

Administrating the Business. The third step in buiding a successful career as a freelance photographer is the process of running your business. That will be covered throughout the rest of this book.

Your reputation as a photographer will be based on what your client sees, not what you shoot.

6. The Photographer as a Writer

In order to succeed in today's image-oriented market as a freelance photographer, you must also be a competent writer. Many of the world's movers and shakers continue to rely on written materials—created both on paper and digitally. They read such things as captions, correspondence, proposals, sales, and promotional materials. All of these materials and communications require more than a basic ability to write a readable sentence.

Correspondence

Not a single day will pass during which a freelance photographer isn't required to compose and send out e-mails and letters. A successful independent businessperson, especially in the world of freelance photography, must have the ability to compose readable job-confirmation letters, information requests, past-due account collection notices, thank-you notes, and general follow-up letters. Communicating with your clients, your market, your business concerns, and a host of other sources and resources is almost always done via the written word. It's the most common requirement in every business.

Most high-school graduates have been required to write reports, essays, and the like in order to become graduates. Few, however, have been taught to write a good business letter. If you don't know how to compose a business letter, or even the style of business letters in general, get one of the many books available on the subject. Also, take the time to review the look, length, and style of letters you receive from places that want your business.

The best advice, regarding business correspondence, is to keep it simple, keep it short, and get to the point as quickly as possible. The people who read your written communications are busy and they probably don't care much about a freelancer who wants their corporation's money. Well-written correspondence will go a long way toward alleviating this attitude.

Review the look, length, and style of letters you receive from places that want your business.

Captions

Every photograph you create must have a good caption—and it must have it as soon as possible after it is created. A photograph isn't ready for the client, the stock agency, your library, or your general file without a complete identifying caption and a copyright sign (©). This requires you to provide four or

five words that can be used by data-processing and search systems to identify exactly what's in the photo.

Caption writing isn't too complicated. A photo of a car is a photo of a car. Or is it? Maybe the car is a classic 1957 Chevrolet Corvette. Maybe it's a bright red one. Maybe it's sitting in front of an old fashioned hamburger stand or gas station. Consider exactly what's in your photo—and keep in mind that the reader of the caption may not be *seeing* the photo when reading the caption, especially when receiving a list of search results.

Good caption writing is mostly a matter of practice. Studying how a successful stock photography agency captions its images will also help. Make sure your captions do the job as well as your competition's captions, because this is how photo buyers search for images to buy.

Most good image-management systems have both visible and invisible caption systems. The visible caption is only a few short words that cover the subject of a photo. The invisible caption is also called a "metadata file" and is buried (digitally) inside the image. This may include detailed information like the date it was created, ISO, lens focal length, shutter speed, your name, a copyright sign, the type of image document, and other information—most of which is more valuable to you than to a photo buyer.

Always keep your captions as simple as possible, and remember that they will be with the image for the life of that photograph.

Proposals

Proposals are the heart of a freelance photographer's sales plans and efforts. Even though they may have started as a conversation with a potential client, most proposals are eventually presented in a written form. After all, the person you spoke with will want something in writing to show their boss and to keep on file. They'll want something to mull over in their mind—something to spell out exactly what you propose to do in creating images for their purchase and use. And, of course, they'll want to see an outline of the costs and benefits.

A good sales proposal should be a written document outlining your ideas, experience, and budget.

A good sales proposal should be a written document outlining your ideas, experience, and budget. It should also include samples of similar work. Most good photography buyers—these are the people whose job it is to request proposals—will take the time to read what you've provided. A badly expressed proposal is usually a failed proposal. Poor writing and spelling, grammatical errors, and improper word choices will contribute to such failures. Well-written materials make it easier to digest and make such selections.

Learning to compose good proposals requires a lot more than good ideas and basic writing skills, though. It also demands some understanding of how a potential client thinks—especially when it comes to choosing one proposal over another. For example, proposals that are too long may seem daunting

and put off the reader. So, it's best not to send a long resume or full-blown biography unless the client specifically asks for one. Instead, you'll do better to outline some of the successful projects you have completed.

Bind your completed proposal in a simple folder; there are several types of business bindings available at copy and printing centers. Keep in mind that the more professional your package looks, the more professional you look. Once it's bound, simply attach your samples and a cover letter. (*Note:* Your written proposal can easily be converted to a digital document and sent via e-mail, if necessary.)

Promotions

No matter what your field of photography, there will always be times when you have an interesting story to tell—and you're the best person to write an article that promotes yourself and your current work. Although the editors of newspapers, magazines, and web sites are as busy as your clients, they are all looking for well-created and interesting materials for their publications. Feel free to send your promotional materials (newsletters, press releases, postcards, etc.) to several editors. Hopefully, at least one will take an interest in the story and call or e-mail you for additional details.

Winning a major job, signing a high-profile client, being given an award—these are all things that media people look for in a promotional piece. In addition to the story itself, a good press release will feature relevant images from your assignment, shots of you completing the assignment, and extended cap-

Reporter's interview notebook and examples of promotional flyers written to promote the authors of this book and their business.

tions. In some cases, the images will be all that editors review (at least initially), so make sure the captions are mini-stories in and of themselves.

Naturally, the more effectively written and presented your promotional piece is, the more likely it is that your story will get picked up by the media. Almost all promotions require the ability to write a "story" that is acceptable to the media in which you hope to get it placed (whether it's your local newspaper, a national magazine, or an industry blog). As with all your writing, keep it simple and to the point. Make sure it's in a presentable package, a format that is acceptable, and—above all—timely. Weeks- or months-old news will not be appealing to most editors.

Whenever possible, address your promotional materials to a real person (preferably the editor). If a Google search doesn't give you the contact information you need, call or e-mail the media outlet to obtain the editor's name.

As with all your writing, keep it simple and to the point.

Editorial Features

News and feature photojournalists often provide clients with detailed information about the events and subjects they photograph. In many cases, these photojournalists also do the journalism part, too, by writing the feature that accompanies their images. This is especially true if they have a basic ability to write an editorial feature in the accepted journalistic style.

Many top photojournalists are, in fact, also top journalists. Having the ability to shoot and write about a given subject affords them easier access and a more wide-spread reputation. It certainly makes them more desirable when the publication's budget can only accommodate sending one person to cover a given story. Plus, a single writer/photographer gets the entire budget that would otherwise have been divided between two people.

Creating editorial features is a fun way to participate in subjects, events, and causes in which a freelance photographer has an interest. You get to interview and photograph people who share your interests. There are lots of newspapers, magazines, and web sites that are starved for good feature articles with good images.

Naturally, one of the best subjects to write about and photograph for an editorial feature article is you and your business. In fact, most successful freelancers keep an on-going (and current) feature story about themselves handy at all times. When they win a major award, the article is up-to-date and ready to go.

Help! I Can't Write (or Spell)!

Okay, so you can't write a single line of readable text or spell the name of your hometown. These may be the reasons you've chosen photography instead of journalism. No matter. If you can read a simple newspaper or maga-

zine article, you can learn to write one. The basics of getting information into a readable form are relatively easy—and you don't have to feel that you must compete with Pulitzer Prize–winning journalists.

You may have heard the journalistic adage about needing to tell who, what, when, where, why, and how. This is the information required for a good story—and these categories should be the basis of your news releases, proposals, business letters, and other written items. Start by writing a single, short sentence answering each of those magic questions (who, what, when, where, why, and how). Stick to the facts and avoid using the word "I." When you're done, you'll have a simple written piece. Writing an understandable feature article is pretty much the same process, but you'll write a paragraph or two on each topic. If possible, add a few short quotes from the major players in the story. To wrap up your story, finish with a brief summary. That's it—it's written.

Of course, there's more to becoming an accomplished writer than this simple outline makes it seem, but this is the beginning of how it's done. The best way to advance your writing skills is by taking a basic news-writing or journalism class at the local community college. From basic writing skills, you will learn how to write a good proposal, press release, feature story, and more. (Who knows? You might even write the next great novel.)

Learning how to write well will be an invaluable asset in your business and personal life. If you can clearly express your thoughts in writing, you can be a success at almost anything.

Hardback pictorial coffee table books authored by Cliff and Nancy Hollenbeck. Such books make excellent portfolios when contacting prospective travel clients.

7. The Freelance Rules of Engagement

Just as in every other business, freelance photography has a set of general rules that control your ability to succeed. Many of these rules are laws and regulations that must be met to establish—and stay in—an independent business. You do not need to be a lawyer or CPA to understand the laws of freelance survival, although it will be necessary to talk with these professionals from time to time.

Even though you may start out as a small business, sooner or later you'll be dealing with larger, more complex organizations and corporations. Often, these are complicated bureaucracies that have little sympathy or understanding for the creative suppliers with whom their marketing and promotion departments work. Don't take this personally; it's just the way business is done in the big city. Before embarking on a significant job, however, you'll want to make sure that all of your legal and financial bases are covered when it comes to keeping records, signing contracts, answering audits, and so on.

Sooner or later you'll be dealing with larger, more complex organizations and corporations.

Governments

Federal, state, and local governments make the rules by which small businesses must operate. For the right to do business within their realm—and in exchange for the services, privileges, and rights they provide—we pay the government a share of our income in the form of numerous licenses, permits, fees, and taxes.

Tax-collecting and governing bodies have little patience with businesspeople who do not comply with their rules, regulations, and laws. It's not personal; it's business. If you want to stay in business for any length of time, and have fewer headaches and hassles, you'll make it a top priority to know and follow their rules.

You may have no idea which forms and permits are necessary to operate a freelance photography business. Likewise you may not know how to complete the forms, permits, and other formalities that are required by the many governing bodies regulating small businesses. You have to learn all of these things before starting a business.

Fortunately, governments have an interest in minimizing the problem of businesspeople failing to meet their requirements. As such, they offer dozens

of publications, seminars, and online resources designed to put you on the right track. Review your state's Department of Revenue web site to see what's immediately available for a small business. This is the very best source of information for getting started in, and operating, a business. The same applies to your city government. (*Note:* If you have already consulted a lawyer, CPA, banker, or business consultant, they have probably answered most of your startup and operating questions.)

Taxes

Compile your taxes well in advance of their due date using a good financial program like TurboTax. These programs eliminate most mistakes made by small business owners who have their minds on other projects. File your tax returns when they are due, even if no money is due. When tax payments are due, pay them before all other expenses. If you're short on funds, it's much easier to negotiate with another business to which you owe money than with the Internal Revenue Service during an audit.

Permits, Licenses, and Authorizations

Every state in the union, and every city in our states, requires that small businesses have a license to conduct business within their boundaries. Some of these governments also require permits to perform certain types of business. Make it your business to research the state and city license and permit requirements wherever you plan to do business. Make it your first priority to meet their requirements before offering your services and photography for sale.

Travel Photographer Nancy Hollenbeck during a brochure shoot in Cozumel, Mexico. Note the warming filter used on the flash to balance it with the bright sunlight.

___Shooting commercial images on public property (such as city and state parks, beaches, fields, and streets) also requires a permit in many cases. Federal property (such as airports, office buildings, courts, national parks, military bases, and the like) will almost always require advance shooting permission and permits. In many cases, it will also require equipment checks, escorts, and location approvals.

Most photography location-shooting permit requirements can be found with a simple Google search or telephone call to the proper authority. Professional photography associations also have members who have shot in just about every location; you might call on them to share the

particulars with you. Be sure to present all of your permit requests as far in advance as possible to reduce the possibility of not getting approval in time for the shoot.

For all commercial shooting assignments, the minimum documentation you need is a letter of authorization from an official in the company. You may also need to provide proof of liability insurance, client identification cards, and similar items.

Record Keeping

With every license and permit comes a fee and/or a tax—as well as the right for the issuing authority to conduct an audit on the records surrounding the business or activity. Successful freelance businesspeople (at least those who want to avoid financial problems) keep a paper and/or computer record of every financial transaction they make. *Everything.*

Managing the Paperwork. Small businesses generate a lot of paperwork—forms, licenses, letters, checkbooks, invoices, promotions, and so on. Keep all the paperwork associated with every job you complete. This includes copies of receipts, shooting expenses, client contacts, designer drawings, correspondence, model releases, proofs, and your notes on the job.

Most of the world's largest corporations are doing everything they can to eliminate the "paper" in their paperwork, utilizing digital files instead—but all of these businesses also have very experienced people entering and maintaining those file systems. They also have extensive backup systems, kept in separate locations, to fall back on in the event of a fire or an electronic system failure. In an ideal freelance photographer's world, all of your records would be kept digitally, too—but until such time as you are one of those large corporations, it's best to keep paper files as well as digital documents.

Your paperwork files, both "real" and digital, are important business records for tax-collecting governments, banks, accountants, and (hopefully not too often) lawyers involved in disputes and tax audits. Keep them safe, clean, and organized—and have backup copies of everything. After your taxes have been compiled and filed, store the year's records away in a safe and fireproof place. Save these records for at least ten years. Save your completed tax-return forms for as long as you are in business, plus ten years.

Project Tracking. Keeping track of the thousands of assignments you will shoot over a lifetime in the freelance photography business will require a lot of time and energy be spent on administration. Remember that the number one rule of business is this: the job isn't done until the paperwork is done.

When a potential client calls you about a job, start a file and keep notes. So that you'll have something in writing, ask them to send you an e-mail with their request, outlining the desired products and services you are negotiating to provide. Respond back to the client in the same manner, making sure to

> **Be sure to present all of your permit requests as far in advance as possible.**

Stock photography of the Twin Towers in Kuala Lumpur, Malaysia. Made with a tripod and a two-second exposure at dusk—approximately thirty minutes after sunset.

list exactly what they can expect to get—what products you plan to provide, the costs, fees, rights, and payment requirements. Don't feel shy about this process; this is also how business is conducted.

As you produce the images, provide the services, and otherwise complete the assignment, keep a record of everything, including material receipts, expense receipts, shooting dates and times, mileage, changes to the original request, approved proofs, computer work, and anything else that applies to the project.

___To keep things organized, assign a unique number to each project you undertake for a client (or for your stock image library). Write the number on *every piece of paper associated with the job,* including invoices, receipts, releases, correspondence, and file folders. Use the same number to organize all of your digital files pertaining to the job. We also include a proof sheet of very small but identifiable images in the project file. Additionally, we try to put as much

To keep things organized, assign a unique number to each project you undertake.

of this information as possible into a digital format, via Word documents, scans, and e-mails. When an assignment or project is completed, put the hard-copy paperwork in a file and save the digital file to a CD/DVD or hard drive (one devoted to storing business documents).

Doing all of this administrative project tracking will allow you to know how much it costs to do certain kinds of image making and assignments. Your proposals and quotes will be a lot more accurate with all of this information at your fingertips. Additionally, should you ever encounter legal or tax questions, these files will be at hand for immediate answers.

Tracking Expenses. Use a credit card, check, or bank transfer to pay as many business-related expenses as possible. This gives you a receipt that is accepted by clients, banks, and governments. Pay cash only when there is no alternative. Location phone calls, equipment porter tips, taxi fares, small model fees, entry fees, cold drinks and snacks for crews, parking meters, and similar items are often paid for in cash and delivered without a receipt. When this happens as a job-related expense, make a written note of the expense, noting the unique job number, date, item or service, and the amount paid. These notes are acceptable as legal records—so long as they aren't for outrageous amounts or items that aren't normal and necessary for the project.

Separate Business and Personal Accounts. Make sure your business accounts are completely separate from your personal or home accounts. The same thing applies to credit cards, telephone numbers, cars, equipment, and similar items. Don't be tempted to use a business account for personal use. This is a red flag to the IRS and other financial institutions. Be strict about doing your monthly updates, reconciliation, and general accounting.

Contracts and Agreements

When you agree to sell a product, provide a service, or complete a task for a client, that's a contract—even if it's not in writing. As you complete work for clients, the terms of oral contracts often become difficult for both parties to remember, so it's better to eliminate any question about the various terms of an assignment or sale by getting the particulars down in a letter or contract of understanding. If problems arise, this written agreement should help sort them out.

Watch the Fine Print. Keep in mind that any purchase order, letter of confirmation, receipt, check, or similar written paper you sign may also be a contract. This applies to clients, suppliers, contractors, and so on. Be sure to read everything before you sign. This is especially true for the fine-print terms often found on the back of documents and checks. Change the wording or completely cross out anything that you haven't agreed to with your client or supplier. There is nothing illegal or unethical about making such changes; this fine print often comes from someone besides your contact inside their or-

> **Your proposals and quotes will be a lot more accurate with all of this information at your fingertips.**

ganization. The same goes with your own documents. Don't put fine print on your delivery memos, receipts, invoices, etc., that doesn't apply to the specific job and isn't approved by the client. Otherwise, they will also make changes and cross out anything they don't approve.

What to Include in Written Agreements. Most freelance photography projects break down to a few simple things, which should be covered in your written agreement. In no special order, some of the things you should consider including are:

1. A description of what will be photographed, where it will be photographed and when.
2. The name of the person who will have final approval for signing proofs and authorizing any changes.
3. Expenses and materials for which the client agrees to pay.
4. The specific copyrights and uses being purchased by the client.
5. The photography fees being paid for by the client.
6. How payments will be made by the client. Include how much will be paid up front to begin the job, the amount and date that intermediate payments are due during the project, and the final payment with image deliveries.
7. The delivery dates for the completed work.

Contracts do not need to be complicated documents with thousands of words.

Sample Contract. Contracts do not need to be complicated documents with thousands of words. The simplest written contract is a letter from you to the client. You sign the letter to them and ask that they sign and return a copy you have provided. A simple letter of agreement might go as follows:

Dear Client;

Thank you for selecting me to produce photography of your (PRODUCT), which will be used in a sales brochure and the company web site.

As planned, I will be at your offices on (DATE) at (TIME) to photograph the (PRODUCT). I estimate that it will take (TIME) to complete the job. I understand that (NAME), from your company, will be making all image approvals during the shooting.

A list of the materials and expenses I expect to incur on this project is attached.

I understand that you will be issuing a purchase order in the amount of (PRICE) for all the expected expenses and one-half of the photo fees. The balance of the photo fees,

and any approved additional expenses, will be provided when the images are delivered. Payment will be made within 30 days of receipt of the invoice and photography.

My paid invoice for all expenses and photo fees will also be your copyright authorization to use the selected images for (PERIOD OF TIME). Additional uses and rights for the photography are available.

I am covered by basic business liability insurance, as is my assistant and any of your property we come into contact with during the photography.

Your images, based on the approvals by (NAME) during the photography session, will be delivered on (DATE). As requested, the images will be delivered in (FORMAT) on a DVD with a proof sheet.

Thank you for working with me on this project.

Sincerely,
(PHOTOGRAPHER'S NAME)

Unless objected to by your client, this simple letter becomes a written contract for the project, even if you're the only one who signs it. If you have any doubts about a client or project, send the letter via certified mail with a return signature card.

Keep your language simple—use terms a stranger to the business will understand. After all, in the unlikely event you have legal problems, strangers in the form of lawyers and a judge will be deciding the outcome. If you are uncomfortable writing your own contract, have a lawyer help with the proper wording. Make sure you understand everything in the written materials you send to clients. Using more complicated contracts generally means having a lawyer take a look for any problem areas, which can mean a legal fee that's higher than your job's profit. Keep it as simple as possible.

Contracts do not need to be complicated documents with thousands of words.

Legal Problems

Now and then there will be a client who, for one reason or other, will be unhappy with you or the work you have provided. You may also be unhappy with a client for any number of reasons. Non-payment of invoices, improper use of images, poor work on your part, and a host of other things can cause problems. Hopefully, such unhappy issues can be settled with a friendly conversation before they become larger and more legally complicated. That should always be your first approach. If a friendly conversation doesn't work, try writing an equally friendly letter and expressing your side of things, stating a desire to settle the matter quickly and reasonably.

When all else fails, their lawyer or yours may write a letter making a demand of satisfaction. If these demands aren't met, to the satisfaction of both sides, the next step may be litigation. That means a lawsuit. Always try to settle things before going to court. Neither you, nor your client, nor any lawyer can accurately predict how a trial—and its expenses—will turn out. Make the decision to proceed to court with your head, not your heart. Being right doesn't always translate into being successful in a lawsuit; even if you prevail, it is almost always expensive.

Make the decision to proceed to court with your head, not your heart.

Freelancers usually learn to avoid legal problems by asking for all expenses and at least half of the photography fee in advance. When selling stock photography, you should request all of the fee before delivering any images. Sometimes, it's difficult to obtain money from a client after the job has been completed, even if they are happy.

It's a good idea to establish a working relationship with an attorney who is familiar with the creative arts *before* you have problems. This person will then be on hand to help with your forms, agreements, and any problems that may develop.

Audits

With every license, permit, fee, and tax return you complete as a small-business owner comes the potential for being audited by the governing body or bureaucracy requiring the paperwork. We can't stress this important part of freelance business enough.

The more accurately your forms and filings are completed—and the less unusual your information, deductions, and the like are—the less notice will be paid by the bureaucracies. Audits are most often conducted when you make a mistake, take huge deductions for unusual expenses, have something abnormal entered, or miss their deadlines.

Do not fear audits. Believe it or not, they are a normal part of business. If you receive notice of an audit, send the information to your CPA and let them handle things. Your job is to create images, not deal with financial problems. Do not accompany your CPA to an audit, and do your best to keep auditors away from your place of business. Don't become so involved in the audit that your business crashes to a stop until it's over. Keep working normally and let your CPA take care of the audit—that's their job, and they are much better at it than you will ever be. Always comply completely, and within the time limits, with the request of an audit. Provide everything they ask for through your CPA.

If you are crazy enough to have broken the tax regulations, committed a fraud, or done anything else seriously illegal—either tax- or business-wise—contact a lawyer instead of your CPA. If necessary, your lawyer will retain a CPA to deal with the audit, making all communications confidential. It's

much better, though, to avoid potential problems by not abusing any laws or regulations.

Insurance

Insurance is not a luxury in a small business. You should insure everything you can't afford to lose or replace. Start with your life and health, then equipment, cars, office, and employees. Do not wait until you've had equipment stolen, a fire, or an accident to get a good business insurance policy. Insurance is one of the basic musts—and it's deductible on your tax returns.

Remember that you represent your client when producing a job, which in itself may have some liabilities if something goes wrong, gets broken, or if someone gets hurt. For these reasons, it's a good idea to have liability insurance. Also, do not assume that your insurance, or your client's insurance, covers you in unusual shooting situations and locations. Working in mine shafts, underwater, in aircraft, in construction sites, in war zones, and similarly hazardous situations is generally not covered by basic business insurance. If you expect to work in such conditions, talk with your insurance agent in advance and get the proper coverage for you, your crew, and your equipment.

It's a good idea to establish a relationship with a good business insurance agent early on in your business life—but be sure to shop around; you don't have to spend a fortune to have a good, basic policy. Some of the professional

Stock Photography at Wild Horse Canyon near Sun Valley, Idaho. Made with natural daylight and a polarizing screen to enhance the blue sky and white clouds.

photography organizations (such as PPA and WPPI) have very good group insurance plans that you should certainly check out. Also, look into comprehensive small-business insurance packages, which often provide a much wider range of coverage than separate policies.

Copyrights

Registering. A freelance photographer owns the copyright to an image the second the shutter is pushed and the image is created—no matter how good or how bad the image. If you are in the business of creating photography for sale, then your images are a valuable commodity. Therefore, the copyrights to your best images should be registered with the U.S. Copyright Office in Washington, D.C. Their official visual arts registration forms can be downloaded from their web site or obtained by writing to their offices (see address on page 110). Instructions for completing the forms are also available through the same resource.

Transfer of Rights. There are many rights that can be sold and transferred. Most rights for photography—whether created on assignment or for stock sales—are for a specific use, or campaign use, and for a specific length of time.

Specific use rights can be transferred, or purchased, for any length of time agreed upon between you and the client, including unlimited use or even all rights. Additional uses, electronic uses, unlimited uses for a certain period of time and all ownership rights are all different situations and should be valued accordingly. That generally means a certain percentage fee increase for each new or additional use. Of course you can, and should, negotiate these terms to the satisfaction of all involved parties.

Make sure you know exactly what the client expects, then put these terms in your assignment confirmation letter. Image rights should always be transferred in writing. Never transfer any rights or uses in an oral contract. Again, the simplest way to transfer use rights is on your invoice, which should spell out all the details of what rights transfer, and for how long, upon your receipt of payment from the client. Also, add a clause to your delivery memo, letter of agreement, and confirmation letter that makes the client responsible and liable for any use of the image(s) not approved by you in advance.

Photography copyright registration package, including federal form, proof sheet of images, disc of small JPEG images to be registered, and certified postal forms.

Rights Violations. Unfortunately, owning the copyright to an image doesn't necessarily protect your images from being "borrowed" and used by unscrupulous people. Digital technology has made it easy for someone to scan one of your printed images, or download one of your images from a web site, and use it as they please. When this happens, owning the copyright to an image gives you a legal right to seek compensation for its unauthorized use.

Work-for-Hire. Freelance photographers who do contract work for newspapers and magazines may be asked to sign a contract demanding all rights

to everything shot for the publication; the photographer hands over *everything*—and usually for the single-job rate. Freelancers not agreeing to these demands are generally never hired again. Do not be surprised or offended when you receive such a contract or requirement from a prospective or active client. To them it's just business.

Documentation

As we've said earlier in this chapter, document in writing everything that happens. When use rights change, assignment terms change, or other changes arise during a project, get them down in writing and send a copy to your client. If you're away from the client's business location—out on location or otherwise shooting without the direct supervision of your client—send an e-mail or make a telephone call for approval.

Property and Model Releases

The First Amendment of the Constitution, which guarantees freedom of the press, allows editorial photography of almost anything and anyone in a public place without permission. This does not, however, allow you to trespass (in person or with a telephoto lens), stalk, or interfere with the life of a person or their property. Also, keep in mind that images without a signed photo release can only be used for editorial publication, not advertising, promotional, or commercial uses.

To shoot pictures of a person, and/or their property, that will be used for advertising, promotion, commercial, and other "for profit" uses, you need written permission. Oral permission is difficult to prove after the fact. A simple model or property release will do the job. It might read as follows:

> The below signed gives permission to
> (PHOTOGRAPHER'S NAME) to photo-
> graph me and/or my property, and to use
> or sell the resulting photos as they please.

This should be followed by the person's name, property description, address, the date, and their signature. Simple release forms are also available at professional photo stores.

Save yourself a lot of time and frustration by requesting and obtaining a signed photo release in advance of photographing the subject. While you do not have to pay a person in order for the release to be legal, it's always nice to compensate a model for their time if you are in a location shooting images for a stock library. Releases are also a must when photographing a client's employees, in every situation.

Freelancers not agreeing to these demands are generally never hired again.

Ethics

Freelance photography can be great fun, allowing you to shoot most anything and any situation. Always use a little common sense when shooting in a situation that may be dangerous, illegal, or improper. The following are a few ethical concerns to keep in mind.

Avoid False Claims. As a freelancer, you must not say you are a photographer on assignment for a certain organization or publication unless you have something in writing to prove that you work for that organization. Before you can say you are from *Playboy* or *National Geographic*, you must have a signed letter of introduction from the publication in your possession—with a name and phone number that can be checked.

Avoid Impropriety. Do not photograph underage children (in any situation) without their parent's permission and supervision. *Never* photograph an underage person in any situation that might remotely be perceived as sexual! Even when dealing with images of adults, you should never allow your images to be used in any manner that would put the subject into a situation that seems illegal, sexual, or otherwise improper. You should state these requirements, in writing, to any stock agency selling your images.

Do not photograph underage children without their parent's permission and supervision.

Avoid Misleading Digital Manipulations. In the hands of an experienced designer or photographer, it is nearly impossible to tell when an image has been significantly changed. Not long ago, an attorney friend watched us work on an image in Photoshop. Our client wanted an image of a couple holding hands to be inserted into an image of the surf at Waikiki with Diamond Head in the background. The couple had been photographed in the surf at a different location, so inserting them into the image was a relatively simple task that took only a few minutes. Although there is nothing wrong, in our opinion, with fixing an image for a client—especially when the final image is something within the realm of possibility—the attorney watched this process and commented that it was easy to see why judges no longer trust most photographs in their courtrooms. He is right.

If you are going to offer for sale images that have been extensively changed from what was in the original scene (images that could not have been created without Photoshop), it's best to let potential buyers know that the images have been changed. Don't try to pass the shots off as representing the actual scene. If you do, you may face legal problems.

If a client wants you to change something, make a written note for your files and make the change. It's their product and money—and they will be responsible for the consequences should a legal problem arise. Your clients will be aware of this potential and may set their own limits. To avoid misleading their readers, for example, editorial publishers need to know if you've changed the content of an image. In hard news, they may not accept anything beyond spotting and color correction. Even advertising agencies, who want their

client's product to look as good as possible, will want to know what you've done to an image. Although they don't have the constraints of the editorial world, it's still not acceptable or ethical to make their product look like something it isn't.

As with most things, this is a matter of degrees. If your image is way off the chart—with bizarre or wildly unrealistic elements that were obviously added or created—you probably don't need to worry about mentioning it was digitally manipulated. Any normal person should understand that this is a creative work of photography and computer art. There isn't any question that the image is a fabrication of your fertile mind.

Conversely, if your final image still looks like the original scene, or as someone would probably find it, this should also be no problem. The fact that you did a few cleanups or made minor changes (like removing a piece of litter from a beach) does not require any sort of disclaimer that digital enhancement has been performed on the image.

Digitally combined image of a couple at a luxury resort against a red Ferrari.

8. Selling Your Photography

A freelance photographer is in business to sell photos. Important as they may be, creating photos, administrating the business, and everything else connected with being in a small business are just the support services. In order to create images and stay in business—and, for that matter, in order to eat—you must *sell*. No sales means no photos and no food. Keep this in mind every day. Consider it in every business decision you make and in every assignment you undertake. Your job is to sell images and services.

The good news is that there are thousands of markets for talented freelance photographers—markets just waiting for you to sell them your images. The bad news is that most photographers are more concerned with making images than selling images. Learn what it takes to make sales and then spend some time every day doing it.

Analyzing Potential Markets

Before you make a single sales call, send a promotional e-mail or flyer, or do any active searching for clients, answer the following questions:

- What products and services are you selling?
- Where and who is the ideal client for your specialty and style?
- How do you find and sell to these ideal clients?

The process of selling as a freelance photographer is fairly simple. In order to sell images and assignments, you need to get your best work in front of clients who need the type of work you are capable of creating.

Using Google, research your potential clients to see the style of photography they currently use. Research the places your potential clients use their photography. Determine who makes the photo-buying decisions and get your name and images in front of those people.

Obviously you can't find and contact every possible potential client that exists in the entire world. You would spend all your time compiling and checking the accuracy of your contact lists. Start simple: research potential clients in your region or metropolitan area with whom you would like to work and who have products you would like to help promote.

Research your potential clients to see the style of photography they currently use.

Creating and Maintaining Client Lists

In the beginning, a good client list is no more than a slightly expanded mailing list.

Use the business, advertising, and media directories available in your local library, and on the Internet, to make a list of the possible clients who use your type of photography and services. This will be your initial client list. In the beginning, a good client list is no more than a slightly expanded mailing list. Compile these contacts using a good data-storage system, which allows you to sort and pull contacts for sending targeted e-mails and letters. There are several items you should include in each individual client listing, including:

- Company name
- Company products/services
- Contact name
- Contact's title
- Street address
- City
- State
- Postal (zip) code
- Country
- Phone
- E-mail address
- Web-site URL

List the buyer of photography as your main contact in a company, and list the equivalent person in their advertising agency. Most often, this will be a marketing, sales or promotion person, an art director or graphic buyer, or (for publications) a photo editor. Larger organizations and publishers will have specific people in charge of working directly with photographers. Directories like the Redbooks (see the resources section on page 102) and company web sites provide this specific information.

There are also list-development organizations that can make your client search easy. Several good web sites allow you to enter the type of client you want, along with the city, state, and country you want. These agencies will provide everything you need, including street and e-mail addresses. Some of the better companies also handle printing and mailing services.

A client list is only as good as its accuracy. Be strict about updating your listings when mail is returned and eliminating unproductive/bad listings. Keep entirely separate lists, or subcategories, of your current clients, past clients, and your most desirable wish-list of clients.

Pricing Images and Services

What is it going to cost me for this shoot? How much is the photo I need? What's included in the price? What rights do we get for the money?

These are the most common questions a freelance photographer receives, and they are often feared by a beginning photographer. You wouldn't think of purchasing a camera without knowing the price, what comes with the camera body, what lenses it takes, and so on. Your potential clients just want to know the same things about your photography and services.

In the business of photography, your services, quality, and experience—not to mention the need to put food on the table—are all factors that contribute to the price of a particular service, photo, or shooting assignment. Some important things to know, before suggesting a price, include:

- What is the client's budget?
- How much have they paid for similar work in the past?
- How many images does the client need?
- How long it will take to complete the assignment?
- Are talent, props, and any unusual materials needed?
- Are there location expenses involved?
- Will extensive computer work be required on the images?
- What will the photography be used for?
- What rights are needed?
- Will you be able to have future use of the images?
- Is there any future value in those images?

When you know all of the client's needs, expectations, and photo uses, you will be able to offer an estimate of costs. As with any creative business, this price is usually negotiable—but remember, it's easier to drop your price than it is to increase it.

The more complex a project, the more time you should devote to providing an estimate and proposal. Most clients will want a bid or quote, which must be met if the assignment is yours. Be sure you have covered all contingencies, adding a small percentage for unexpected changes and developments. Clients don't like surprises, and the better photographers don't let them happen.

Figuring out prices and rates is easy. Total all the anticipated costs to complete the project, adding a little for unexpected things and including the profit you want to make. That's it. Enter everything in a financial program or smart word-processing table. This will allow you to review and revise the numbers. Microsoft Excel is an excellent program for budgets and estimates, as is Microsoft Word. Most clients will want your estimates and bids to be presented in writing and broken down by expenses. This makes it easier for them to compare you with other photographers and track it with similar projects.

Some photographers mark up every item they buy, plus charge a fee based on the use and value of the final photography. For example, if the image you

make (or have, in the case of stock sales) will be used in an advertising campaign that cost $10,000, ten percent of that amount isn't out of line as a photo fee. Expenses will then be added on top of that. Also, make sure you know (and tell your client in advance) of any local, state and federal taxes that may be applied to any part of the expenses, fees, and other costs.

Don't nickel and dime your clients. Have a modest contingency fee for the small stuff. Meet your budget. If a major change is implemented by the client, let them know what the costs will be. Don't make any changes in the cost of a job yourself, unless it's to revise the costs downward. Clients like coming in at or under budget, and their happiness is often shown by offering future work. The opposite is also true.

Selling Your Photography

Direct Mail/E-Mail and Phone. While there are dozens of ways to get your work in front of potential clients, in the beginning you should concentrate on a simple approach. Send everyone on your client mailing list a printed flyer, postcard, and/or a brief e-mail showing a small sample of your best work. Follow these communications with a personal note, e-mail, or phone call to ask if the client would like to see your portfolio and talk about ideas. Clients like photographers who have ideas about making images that will help sell their products.

When you send unsolicited e-mails, be sure to enclose an e-mail address that allows recipients to have their name removed from your lists. While most photo buyers and designers want to review brief promotional materials from

Travel photographer's promotional brochure, used in mailings to show prospective clients the type and extent of work available from the shooter.

Promotional photography postcards used for regular mailings to prospective clients. Postcards are an excellent and economical sales tool.

talented new professionals, some don't. Don't let their lack of interest keep you from trying with more accommodating potential clients.

Show your portfolio, in person or via e-mail, as often as possible. Then, follow up on all client contacts with a thank-you note or e-mail, including a new image they haven't seen. Do the same thing a couple of weeks later with a new flyer, new postcard, or new e-mail image. Many successful freelancers never need any more than this simple sales plan.

When you do get the opportunity to make a portfolio presentation, do some advance preparation and research on the client. Try to obtain, or review online, copies of their most recent annual report, magazine, news articles, and related materials. Knowing something about the company will allow you to ask intelligent questions and offer useful suggestions for photo projects.

Advertising. Advertising pages in business directories and newspapers, web sites, photo disks, photo videos, and similar materials are all excellent sales tools. They can also be very expensive for the beginning freelancer. A word of advice: don't put your entire life savings into a single advertising campaign. Make your sales calls, and expand your marketing budget as your business expands. Make a few small trial efforts to see what works and what doesn't. Don't expect overnight success. Building a name and reputation takes time.

Agents and Representatives. Many of the leading freelance photographers utilize the services of agents and representatives. These are people ex-

perienced in making sales efforts to image buyers and presenting the work of the photographers they represent. They are also experienced in negotiating assignments, packaging sales, and presenting your work. They are not shy about calling on lots of clients and they know how the sales process works in the real world. Agents can be expensive in the beginning, often requiring a base retainer and a percentage of your gross income. They are also selective—they want photographers who have real talent. The more established your reputation, and the more work you've done for clients, the more desirable you will be to a good agent.

Selling Yourself

Your photography talents, style, rates, and availability are probably very similar to other freelance photographers in your specialty and area. All things being equal, why should a particular client work with you instead of someone else?

The answer to this question is you—your attitude, manner, look, and personality. In addition to all the photography talents and prices, clients want to work with pleasant, well-mannered, prompt, organized, and clean people. You are selling more than photography, you are also selling yourself. Make sure you are well prepared in all respects for every sales effort. This goes for all communications, sales materials, and samples.

Show potential buyers a little bit of yourself, as well as your work.

People deal with people. This means they want to hear from you more than they want to receive an anonymous e-mail or printed flyer. Show potential buyers a little bit of yourself, as well as your work. This might include an informal biography of yourself and your work and a photo of you working—in addition to your sales materials.

Self Promotion

Every time you complete an interesting assignment, win an award, sign a new contract, publish an article, open a new studio, photograph a celebrity or Fortune 500 business, or do anything that makes you look good to clients, let them know. Do this with short press releases and photos sent to trade and local publications and web sites—as well as everyone on your mailing and e-mail list. You can also try to get yourself invited to show your work on television talk shows by sending the programs' producers copies of your media releases and interesting work.

This is known as public relations, promotion, or "almost free" marketing. Using this technique, getting a good photo of yourself working on assignment to run in a local newspaper may cost only the materials and postage needed to announce your latest success—or even just the time it takes to send an e-mail. The same space in advertising would cost hundreds of dollars. Take advantage of this type of marketing.

9. Your Portfolio

The images you show to clients in the hope of making a sale are generally referred to as a portfolio. Throughout your career, a portfolio of one sort or another will always be your primary sales tool.

Portfolios in General

Portfolios come in a variety of forms, from a few images sent via e-mail to an extensive and complicated web site of images, products, services, and related information. In the early days of photography, before the digital age, a portfolio was a book of prints and printed items from previous jobs.

No matter what format you choose, your portfolio should be changing and growing as you change and grow. Most experienced freelancers have a huge selection of images from which to assemble a portfolio, and they assemble specific portfolios for a specific client or market. The longer you're in business, the better you will be able to assemble different portfolios for different markets.

Even in specific markets or fields, however, clients will often have different needs. For example, in travel photography, one client may sell cultural or recreational tours, another may specialize in general destinations like Mexico or Hawaii, and yet another may offer exotic or adventure packages. Make sure you know what a potential client needs in advance, then assemble a portfolio that reflects those needs and your ability to fulfill them.

The Best of Your Best

No matter what the format, you should show only the best of your best images in a portfolio presentation to a prospective client. Your image presentation will be remembered by its overall quality, which many viewers will judge by the poorest image presented. In other words, a chain is only as strong as its weakest link.

Portfolio images should stand on their own without a word of explanation. No matter how hard an image was to make, how many hours it took, or how expensive the process was, the image must stand alone for its viewing impact. Nothing else matters to the potential client. Either the image is good enough to make them want to work with you, or it isn't.

Fashion model shows off her print portfolio. Binders with examples of a photographer's work are excellent tools in face-to-face sales calls.

Be selective and focused in building your portfolio. Show only the type of work you want to shoot, the style you are capable of shooting, and the subjects at which you are the best. For example, if you are an industrial specialist, do not show images of flowers, sunsets, or topless babes. This may sound a bit obvious, but many photographers load their portfolio up with images they think the client will enjoy seeing, but which have little to do with their specialty or capabilities. You can't be everything to every client, nor should your portfolio attempt to include several specialties of work.

Present images that will encourage the viewer to hire you. If it's an art director, include a few creative, leading-edge images that they will appreciate for the sake of art and design. If the client is doing the viewing, show some images that display your ability to shoot and sell their product. Avoid using stereotypical photos to show off your work; they've probably seen those same shots already. Present the most exciting and motivating images you have available. Your portfolio is a sales tool, an advertisement of your work.

Show some images that display your ability to shoot and sell their product.

Clips and Prints

Most clients, and their designers, like to see work you have created for other clients. Such materials show that you are a working professional. It tells them that others have had success with you as a photographer—and everyone wants to work with a successful person. If you have printed sheets from client advertisements, brochures, or other uses, they make excellent examples of how your work has been used. Get as many copies of these items as possible for future selling. The same goes for images used on noted web sites. Prepare good quality digital files of the best of these materials for use in e-mails, on your web site, and for printed flyers.

Beginning freelancers may not have examples of images created for assignments to show prospective clients. This isn't a problem. Photography buyers are looking for good work above all else and can tell if you're right for their assignments from stand-alone images. Even the most established freelancers have a few non-purchased and non-published images in their presentations. It's the way to show experimental styles and concepts, personal work, and new ideas that are just waiting for the right client. (*Note:* Using high-quality photo prints of your best images will most effectively display your creative ideas and shooting ability.)

How Much is Enough?

Too much of a good thing can be wonderful, or so a famous actress of the last century was fond of saying. The same can't be said of photography presentations, portfolios, and web sites.

Ever have a neighbor show off the photos from their son's wedding or daughter's graduation? After the first handful of prints or computer screens,

only the parents have any interest. Everyone else is asleep or sneaking back to the bar for a quick escape. The same goes for viewers of your sales-presentation images. Keep the viewers' attention with a few great images. Don't give them a reason or opportunity to escape to another photographer.

In the beginning, you'll be tempted to show every great shot you have ever created. Don't do it. A good portfolio shows just enough to pique the viewer's interest. It should leave them wanting to see more. Display your best twelve images in as large a size as is practical for the portfolio format being used. That's enough to demonstrate the range and quality of your work to anyone. If the potential client wants to see more examples of your work, they will ask.

Portfolio Formats

There are several formats an image presentation portfolio can take. A successful freelancer researches all of the possibilities and makes their portfolio decision based on two things: what they can afford to create and what format appeals to the potential clients. A few of the more popular formats are described here for your consideration.

Notebooks. A booklet or binder with a series of your images and printed pieces is easy to review. It also gives the prospective client an idea of exactly what your work will look like in the printed form, which is still one of the most common uses for purchased images. Professional photo supply stores and web sites have dozens of interesting notebook-type portfolios. Make sure you include a page of your business information, so that misplaced books can be returned when found.

CDs. Today's digitally oriented designer, and many of their clients, generally like to review images on their computer screen. They often do this in the same photo-management software you use, such as Bridge, Photoshop Lightroom, or Aperture. A series of low-resolution JPEG images can easily and quickly be put on a CD and sent to potential clients. Don't send high-resolution images, though, or you risk having them go astray and being used without your authorization.

Some photographers like to produce short visual programs of their images using one of the many movie-creation programs. These allow you to create a sequence of images that flow to the sound of background music and perhaps a little dialog. Placed on a CD and sent to prospective clients, these can be very nice examples of your images and creative ideas. A small web site can also be written to a CD, making a good portfolio presentation.

E-Mail. Sending an image presentation via e-mail is one of the easiest, quickest, and least expensive ways to show off your work. The most basic of e-mail presentations is a Photoshop-created contact sheet of a dozen or so images. Size the sheet to the average computer screen, save it as a lower-

Client image package, including proof sheets and a disc of high-resolution images.

Photographer's portfolio that holds laminated tear sheets of printed materials. This is a nice package that can be mailed or hand carried to potential clients.

Laminated tear sheets showing the range of work and publications utilizing a photographer's work.

resolution JPEG, and it's ready to send to prospective clients. You can also take the e-mail presentation a big step further using the techniques described above for CD presentations. These files will be larger, though, and generally require a high-speed web connection for both the sender and receiver.

Printed Materials. Newsletters, flyers, postcards, and brochures are very attractive ways to present your images. With today's digital printing, you can create dozens of interesting, high-quality printed items to send to clients. Most of the better print suppliers will be happy to provide samples of the various items they offer, along with a price list and design requirements.

Some photographers like to send a different postcard or newsletter out every two or three months, just to keep their name on clients' minds and update them on what's new. These printed items are also an excellent way to cre-

An *Alaska Airlines* magazine cover featuring one of the author's photos. Items like this make great mailings to prospective clients.

ate "published" materials early on in a career, when you don't have very many examples of client uses to show.

Pictorial Books. There's nothing like a pictorial coffee-table book to show off your photography. A high-quality and interesting book is something substantial that a client can hold in their hands. It's something that often ends up on real coffee tables for a long time. Having a published book also makes you an author, which helps create a positive reputation. While publishing isn't an easy or inexpensive undertaking, there are two options available.

The first option is to work with a traditional publisher. Publishers are always looking for ideas that will sell in traditional book-selling outlets *and* to corporate clients. You have to approach these publishers with good ideas, just like you would other clients. Keep in mind that the publisher controls what is published, how it is placed, and the design of the book.

The second option is to publish your own book, making as few as a dozen copies at a time with a digital printing company (see the resources section on page 102). This is a good way to go if you are creating the book as a marketing tool, not for sale in book-selling outlets. Printed sales materials, such as the items mentioned in this chapter, are not made for resale, thus they are tax deductible when they are created. Additionally, you get complete control over what is published, where it is placed, and the design of the book.

> **It's just so easy for a potential photo buyer to check out a web site.**

Your Web Site

Whatever method and format you choose to present your photography, include a web site as well. For the foreseeable future, web sites will remain the most common way for clients to view a potential photographer's work. It's just so easy for a potential photo buyer to check out a web site—in fact, a lot of the photography they are buying may be destined for use on a web site.

Web sites seem easy to create—and, as a result, there are a lot of poor-quality, difficult-to-use web sites out there. Before creating your own web site, take a little time to examine the web sites of photographers in your specialty. Then, take a little more time to examine the web sites of prospective clients.

Get help creating your web site. Working with an experienced web-site designer will ensure that your web site looks good and works easily. Follow all the suggestions in this chapter when it comes to what's included on your web site. This is a portfolio and should represent your very best work, not everything you've ever photographed. Be sure to include a little of your personal work and a little information about yourself. Also, make sure you have an easy way for viewers to contact you directly from the web site.

Presentation Certainties

Whatever formats you choose for presenting your photography, do not scrimp on the production of that portfolio. Use the best materials available, the best possible prints or scans, the highest-quality production values you can afford, and an equally creative delivery package or presentation format. In most cases, your presentation package will be the only chance you have to introduce yourself and show the quality of your work. A poor-quality reproduction, even of a great shot, will be remembered as a poor presentation.

The realities of the freelance world are that your portfolio will be compared to several others, including the portfolios of those photographers currently being used by a client. Everything you show, including yourself, will be remembered in the comparisons. Everything you do and say will also be judged against the very best the viewer has ever seen.

Regardless of how your portfolio is seen by a potential client, let the images do most of the talking. A good portfolio image will draw a comment or e-mail from the viewer. Pay attention to creative and critical comments of viewers. Do not offer any comment, unless it's something that adds to their thoughts and needs.

Most portfolio viewers already have a stable of good shooters. They are looking at your images, printed materials, and web site because of the need to always improve—because there is constant change in the marketplace. They are seeking new ideas and new talents to make their own ideas come to life.

After a friendly follow-up reminder, they may think your style is just right.

It was mentioned previously, but it's worth repeating: when you make a personal presentation of work or learn that a potential client has seen your work, follow up with a thank-you note that concludes with something like, "Please call or e-mail me anytime you want to talk about new ideas." Follow up again in a month or so with something they haven't seen in your last presentation. The world of marketing is constantly changing and, after a friendly follow-up reminder, they may think your style is just right. You may also have some new and exciting shots to show. Make sure you do.

Resources

While we have tried to provide as much good information as possible in this book, it's also important to learn from other resources. Therefore, in this section we have made recommendations to help you meet this learning goal. We've tried to list a few of the best resources, in no particular order of importance, as they relate to the subjects covered in this book. These suggestions are meant to be a starting place for your lifetime library of reference materials, web sites, and contact information.

We know the work and respect all of the authors, photographers, and companies recommended. While a number of the books are published by Amherst Media, including this and several of our own books, they exert no influence of any kind in our recommendations. We think Amherst Media is simply the leading publisher of the best books available on photography.

The web sites, various organizations, products, books, and business sources that are recommended throughout this book were accurate at the time of publication. Change is inevitable, though, so some of them may no longer be active at the time you're reading this. Please feel free to let us know when this happens—or if one of the resources is not suitable for any reason. We're interested in your suggestions and comments. You can send an e-mail to Amherst Media, to the authors' attention, by going to www.AmherstMedia.com.

The best value gained in researching the world of freelance digital photography is that it allows you to learn from the mistakes of others—often the best in the business—instead of spending all the time and money required to make those inevitable mistakes yourself. We hope this list helps you toward that goal.

Business Books

Unless otherwise noted, you'll have no problem finding these books at major book retailers, such as Amazon.com. If you live near a well-stocked camera store, you may also be able to find them there.

Big Bucks Selling Your Photography, 4th Ed.
Cliff Hollenbeck
Amherst Media, 2008

Modesty does not prevent us from recommending this book on the business of freelance photography. *Big Bucks* offers a commonsense approach to marketing, sales, administration, and the philosophy required to be successful as a freelance digital photographer. It's an excellent resource for aspiring and professional photographers.

Photographer's Market
Writer's Digest Books, annual

One of the most complete resources available on the markets for (and selling of) photography. The yearly book contains specific contact information on hundreds of freelance markets, including magazines, book publishers, greeting card and calendar publishers, stock photography agencies, galleries, art fairs, contests, and advertising agencies. It also has up-to-date articles and interviews from noted professionals. Extensive sections are presented on wedding and portraiture photography, photo representatives, workshops, and portfolio reviews. It's a very good investment for photographers at all levels.

Sell & Re-Sell Your Photos
Rohn Engh
Writer's Digest Books, 2003

This is one of the essential guides to the business of creating and selling stock photography. It contains plenty of

good marketing, business techniques, shooting information, and resources. It is authored by the leading force behind the PhotoSource group of photography services and publications (www.photosource.com).

SellPhotos.com
Rohn Engh
Writer's Digest Books, 2000

This is an excellent resource and guide for freelance stock-photography sales in the digital age. There is also a Chinese translation available, in case you want to get a look ahead at the next major international market. As with his other books and publications, there is a lot of marketing, business, and shooting information in this book.

Negotiating Stock Photo Prices
Jim Pickerell
(www.pickphoto.com/guide.asp)

This guide to pricing stock photo images was written by one of the leading stock photographers/stock agency people in the business. It is also the guide many art buyers use when dealing with photographers. It's updated frequently, as are the rates paid for images, so be sure to get a current edition.

New Tax Guide for Writers, Artists, Performers, and Other Creative People
Peter Jason Riley, CPA
Focus Publishing, 2009

This is an excellent guide to administrating the often-overlooked tax side of the freelance photography business. It covers everything needed to comply with the federal tax code—and that's saying a lot. Written in simple and effective language, it will help you talk more knowledgeably with accountants, bankers, and auditors.

Standard Directory of Advertisers
Standard Directory of Advertising Agencies
Advertising Redbooks, annual
(www.redbooks.com/nonsub/index.asp)

This is the most complete listing of regional and national advertisers—and the very best and most complete listing of regional and national advertising and public relations agencies. Both books contain detailed information, such as names, addresses, phone numbers, e-mail addresses, web-site URLs, gross sales, advertising budgets, and their advertising agency contacts. These annual publications are the first step toward researching and building a solid sales contact list.

Literary Marketplace
Information Today, Inc., annual
www.literarymarketplace.com

This is the most comprehensive directory of American and Canadian book publishers and their related suppliers. It contains names, addresses, phone numbers, e-mail addresses, and web-site URLs for more than 30,000 companies, books, periodicals, awards, courses, events, and other important information about the publishing world.

How to Sell Anything to Anybody
Joe Girard and Stanley H. Brown
Fireside, 2006

Joe Girard is literally the world's best salesman—he's in the *Guiness World Records*. His very successful philosophy is available for your own use in this quick and easy-to-read book, in which he tells all there is to know about generating sales in any business. A companion book called *How to Sell Yourself* (Grand Central Publishing, 1988) is a nice addition to this author's successful guide to sales.

How to Get Control of Your Time and Your Life
Alan Lakein
Signet, 1989

This is the organizing-your-life handbook for successful businesspeople who sell their time and services, regardless of their profession. Put this book on the very top of your "to read" pile. It's been around for quite a while because it continues to be the best guide to taking control of your time.

Photography Books

Unless otherwise noted, you'll have no problem finding these books at major book retailers, such as Amazon.com.

The Book of Photography:
The History, The Techniques, The Art, The Future
Anne. H. Hoy
National Geographic, 2005

This is an excellent place to get a sense of the truly amazing world of photography, as presented by National Geographic, which was there for most of this developing history. Spanning more than 166 years of photographic history and the work of more than 250 photographers, this comprehensive and colorful book features every aspect of photography, including technical and aesthetic developments, and the personal stories of great photographers worldwide.

Through the Lens:
National Geographic's Greatest Photographs
Leah Bendavid Val
National Geographic, 2003

This expansive and beautiful book celebrates more than a century of collecting and publishing photographs from around the world. The National Geographic Society's photographers have set the standard for nature, culture, industry, travel, environmental, and wildlife photography. This book features master photographers from the late 1800s through today, including David Doubilet, David Alan Harvey, Jodi Cobb, and William Albert Allard.

National Geographic Photography Field Guide:
Action/Adventure
Bill Hatcher
National Geographic, 2006

If you want to advance beyond casual recreation and travel into the world of adventure photography, this book is the next step. It features excellent advice, shooting tips, and techniques presented by one of the world's finest photographers.

Digital Photography Boot Camp, 2nd Ed.
Kevin Kubota
Amherst Media, 2008

Kevin Kubota's "Digital Photography BootCamp" work-

shops are very popular with professional photographers throughout the United States, and his comprehensive approach to digital capture and workflow is available in this comprehensive book. Step-by-step instructions and screen shots are provided for each procedure, making it a very handy book for digital photographers.

Digital Capture and Workflow
for Professional Photographers
Tom Lee
Amherst Media, 2007

An advanced guide for prolific digital photographers who need to deal with a substantial image workflow—and do it efficiently. Start-to-finish techniques are included to ensure the best-possible sharpness and exposure along with consistently good color. The author also covers Photoshop retouching and a wide variety of related plugins.

Event Photography Handbook
William Folsom and James Goodridge
Amherst Media, 2008

This interesting book outlines the important steps necessary to build a freelance event-photography business, from finding customers, to selecting the best equipment for the job, to planning the photography of a wide array of events, including anniversaries, religious ceremonies, business mixers, ribbon cuttings, rodeos, sporting matches, and VIP events.

Garage Glamour
Rolando Gomez
Amherst Media, 2006

Renowned glamour shooter Rolando Gomez teaches everything you need to know about creating elegant and glamorous digital photographs. His suggestions and tips will help you with all aspects of creating images, working with talent, and shooting on location. He covers all the skills, equipment, and props necessary to succeed, making it easy for photographers at all levels to get outstanding results.

Landscapes: Photographs of Time and Place
Ferdinand Protzman
National Geographic, 2003

A beautiful collection of stunning nature and landscape

images created by the photographers of the National Geographic Society. This is an excellent pictorial resource that will provide you with lots of ideas in creating your own images.

National Geographic Field Guide to Photography: Digital
Rob Sheppard
National Geographic, 2003

Professionals and amateurs alike will find this field guide to digital photography a valuable resource. It provides a step-by-step guide on everything from picking the right camera and lenses, to using digital equipment in normal and unusual ways to create images.

Professional Portrait Photography
Lou Jacobs Jr.
Amherst Media, 2008

This excellent book takes you behind the scenes with ten top professional portrait photographers to learn the secrets behind their artistic and financial success. Every aspect of the portrait business is covered, including equipment, working with clients, and sales and marketing techniques. Shooting techniques for studio and location portraits, as well as engagement, family, and senior portraits, are included.

National Geographic Photography Field Guide: People and Portraits
National Geographic, 2002

This excellent guide covers portrait lighting, cameras, and lenses, along with candid and posed techniques for photographing family, friends, and other interesting subjects on location. Includes easy instructions from accomplished National Geographic people photographers.

Children's Portrait Photography
Sandy Puc'
Amherst Media, 2008

Acclaimed children's portrait photographer and photography instructor Sandy Puc' guides you through designing a complete "kid care" photography system. Covers tips for offering her "ultimate portrait experience," including ideas for greeting clients as guests, providing an area with activities for toddlers to teens, the secrets of eliciting expressions, and techniques for lighting and posing. Sandy also includes an interesting section on designing a kid-friendly studio.

Creative Lighting Techniques for Studio Photographers
Dave Montizambert
Amherst Media, 2003

Learn to control highlight and shadow formation to create images that capture the unique shape, color, texture, and character of your subject. Written by an accomplished photographer, the book features images from real assignments, and other practical examples that illustrate each idea.

Softbox Lighting Techniques for Professional Photographers
Stephen Dantzig
Amherst Media, 2007

The softbox is one of our favorite tools for location and studio photography—and Stephen Dantzig is a master at lighting with these creative and versatile units. His guide includes detailed discussions, tips for placing and modifying the light, selecting the right size and shape, and combining softboxes with other lights to ensure the ultimate control. The book is a valuable tool in creating natural-looking lighting for a variety of subjects.

Master Guide for Team Sports Photography
James Williams
Amherst Media, 2007

This introduction to team sports photography covers the skills you need to be successful in this fast-moving and complex specialty. It teaches you how to select the right equipment, find work, hire reliable assistants, and how to work with kids, coaches, and school personnel.

National Geographic Photography Field Guide: Travel
Bob Caputo
National Geographic, 2005

Everyone who travels with a camera is a travel photographer, according to the National Geographic Society—and that magazine's photographers are among the very best. This is an excellent field guide to producing beautiful travel photos. It features work and techniques by some of the magazine's leading travel photographers.

101 Tips for Travel Photographers
Bob Krist
Photo Tour Books, Inc., 2008

If you love to travel and take photos, this is an ideal place to start planning your next journey. *National Geographic Traveler* magazine photographer Bob Krist shares some of the techniques that have made him one of the very best. Plenty of tips, ideas, and examples of his work appear in this handy book.

Master Guide for Underwater Digital Photography
Jack and Sue Drafahl
Amherst Media, 2005

This is a wide-ranging guide on the exciting world of underwater digital photography, written by two of the best in the business. It covers the selection and use of camera and underwater equipment, exposure options, lighting strategies, proper color balance, sharp focus, and close-up/super-macro photography. Their information and tips include solid digital information.

Adobe® Photoshop® for Underwater Photographers
Jack and Sue Drafahl
Amherst Media, 2006

A very good companion to their *Master Guide for Underwater Digital Photography*, this book provides a step-by-step education in using Photoshop to address the unique image problems often found in shooting underwater photography. Teaches you to correct color, exposure, and contrast problems, as well as to remove backscatter, artifacts, and distracting elements, with quick image-editing settings.

The Best of Wedding Photography
Bill Hurter
Amherst Media, 2007

This book will help you discover how wedding photography has evolved into one of the most creative fields in the business. It features tips and images from forty-five premier wedding shooters, including how to choose and use cameras and lighting equipment, meet the challenges of lighting on location, and pose subjects. These are valuable techniques needed to create beautiful images.

Step-by-Step Wedding Photography
Damon Tucci
Amherst Media, 2008

An excellent guide to operating a successful wedding photography business and creating beautiful images at every event. Covers tips for conducting a client consultation to ensure their needs are well matched to your what you can provide, selecting the best equipment, and what shots you must capture at the site of the ceremony, during the reception, and off site. Simple directions for posing the bride, groom, couple, attendants, and the family are provided, as are helpful discussions on selecting lighting. An additional section covers post-production using Photoshop and some intriguing plugins.

The Best of Wedding Photojournalism, 2nd Ed.
Bill Hurter
Amherst Media, 2010

This book will show you how award-winning wedding photojournalists capture the fleeting emotions and romantic moments of a bride and groom's special day in a pictorial story form. Features the ideas, techniques, and images that thirty-five pros use to document each moment as it unfolds. This book is a resource for photographers who want to produce creative wedding images that are spontaneous, full of action, and steeped in emotion.

Wedding & Portrait Photographer's Legal Handbook
Norman Phillips and Christopher Nudo
Amherst Media, 2005

A comprehensive and important business and legal guide to wedding photography. This book provides sample letters, contracts, and forms that serve as a critical resource for every wedding and portrait photographer. It is written in a simple, straightforward language you'll be able to understand without a law degree.

Magazines
PDN (Photo District News)
www.pdnonline.com

PDN magazine is one of the best sources for photography news, legal issues, new technologies, interviews, portfolios of current and upcoming shooters, marketing and business advice, photographic techniques, and more.

PDN Online covers breaking news stories and much of the same information as its print edition. There are many good resources among the advertising pages, which also include some the best current examples of commercial photography.

Professional Photographer

www.ppmag.com

Professional Photographer has been the official magazine of the PPA (Professional Photographers of America) for more than a hundred years. It is an excellent publication for wedding, commercial, portrait, landscape, and general commercial photographers. It features the latest trends, techniques, and technologies, which are always presented by successful and experienced working professionals. You do not need to be a member of PPA to subscribe, although it's provided as a membership benefit.

Communication Arts

www.commarts.com

Communication Arts is one of the oldest and most prestigious creative arts magazines. They feature some of the best articles, top portfolios, and leading competitions in graphic design, interactive design, photography, and advertising. Its annual "Best Of" editions feature the best images and shooters in the world.

Nikon World

www.nikonworld.com

This publication is an inspiring showcase of images, techniques, and insights from Nikon-wielding photographers. It's an excellent resource for ideas, no matter what equipment you use.

EOS

www.eos-magazine.com

This publication is an inspiring showcase of images, techniques, and insights from Canon EOS–wielding photographers. It's an excellent resource for ideas, no matter what equipment you use.

Macworld

www.macworld.com

Macworld is the premier source for news, reviews, help, how-to programs and podcasts for the extended Apple community of hardware and software. That generally includes Mac, Apple software, iPod, iTunes, and the iPhone, and their related accessories. This is a good place to keep track of developments in the computer world, which are often important to a freelance photography business.

Camera Arts

www.cameraarts.com

A beautiful magazine specifically aimed toward the medium- and small-format artistic photographer. Features in-depth interviews with portfolios produced by respected photographers, hands-on new and used equipment reviews, museum and workshop listings, and technical "how to" information.

National Geographic magazines

www.nationalgeographic.com

This is the home of several excellent magazines all featuring the very best in photography. Just about every kind of photographic subject has been featured in *National Geographic, National Geographic Traveler, National Geographic Adventure,* and their other publications. A very extensive set of DVDs also feature every *National Geographic* ever printed. The information and photos are a huge resource for freelance photographers and travelers alike.

Rangefinder

www.rangefindermag.com

A first-class magazine for professional and aspiring freelance photographers in all specialties. Covers a huge range of subjects each month, including equipment reviews, technical information, instructional articles, marketing stories, computer technology, and lots of the current best work being created by leading photographers. Prolific author Bill Hurter is the editor.

AfterCapture

www.aftercapture.com

A premiere publication for photographic digital postproduction work, this magazine also provides online multi-

media resources, tutorials, blogs, and audio/video podcasts. Some very nice images and information are featured in each edition.

PhotoMedia
www.photomediagroup.com

This beautiful, professional-photography magazine targets serious creators and users of photography, offering educational and inspirational articles on all aspects of the field. Its editorial information encourages readers to consider new products, services, techniques and opportunities, while including features about the foremost photographers of the day, industry trends, special locations to photograph, industry news, technical features, and new product reports.

Photoshop World
www.photoshopworld.com

Photoshop World is the best place to learn the current techniques for Photoshop, Photoshop Lightroom, and other Adobe software programs. It's sponsored by Adobe and staffed by Adobe-trained experts.

Traveler Overseas
www.traveleroverseas.com

The Traveler Overseas Club is an exclusive organization of afficionados with a passion for music, food, wine, art, adventure, photography, and everything else associated with the world of travel. Membership provides access to expert advice from professional travelers, exclusive high-end trips, a travelers' forum, and complimentary subscription to the beautiful *Traveler Overseas* magazine.

PRINT
www.printmag.com

A beautiful magazine about visual culture and design, *PRINT* documents and critiques commercial, social, and environmental images from every view. It regularly features the best work in the world of print, design, and photography.

F-Stop
www.fstopmagazine.com

This online photography magazine, which is published bimonthly, features contemporary images by established and emerging photographers from around the world. Each issue features a different theme or an idea that unites the photographs to create a dynamic dialogue among the artists.

Professional Resources
PhotoSource International
www.photosource.com

PhotoSource International is a very good place for photographers who want to sell their stock photos, and for editors and art directors who want to buy their images. For more than twenty-five years, it has provided a host of valuable services, resources, and information for working and aspiring photographers. Samples of their many user-friendly programs can be viewed by visiting their web site. Their marketing and sales notes and newsletters are updated frequently. They also present online libraries and portfolios of members' images, biographies, and specialties. The staff and programs at PhotoSource are among the best in the digital photography business. Their mastermind, Rohn Engh, has authored a number of excellent books on selling photography, which are highly recommended in our book section.

Microsoft Professional Photography
www.microsoft.com/prophoto

Through its extensive network of web properties, Microsoft provides freelance photographers with access to a variety of resources, including developer tools, download resources, communication forums, and product information services. It also presenta some very good galleries, articles, software developments (no surprise), photographer profiles, and lots of support ideas. Everything Microsoft touches turns into pure gold, and its foray into professional photography is proving to be the same.

Creative Shake
www.creativeshake.com

Creative Shake is an online resource showcasing creative talent—including art directors, creative directors, marketing managers, publishers, and photographers. They promote members through branding, marketing cam-

paigns, and strategic partnerships aimed at garnering assignments for freelancers and job-seeking creative professionals. A job board service, online promotion services, self promotion programs, and portfolio maintenance are also included.

Photography.com
www.photography.com

This is a comprehensive online source of information for amateur and professional photographers. They provide in-depth articles and reviews on everything from equipment to techniques. Users share tips and get advice from other users in several forums. The site also provides an interesting online photo-sharing service that offers participants a good way to store, organize, and share photos across multiple social groups.

Planet Point
www.planetpoint.com

Planet Point is a membership-based marketing and sales site, billing itself as a place "Where Creative Talents Are Found." It's a good place to present your portfolio, review successful portfolios, and find creative services such as copywriting, stylists, agents, filmmakers, production managers, and sales representatives.

Getty Images
www.gettyimages.com

Getty Images has the largest collection of stock photography in the world. Its web site is an excellent place to see what's being created and what's being sold by thousands of successful photographers. It licenses rights to still photography and motion-picture footage—and nearly 100 percent of the company's visual materials are delivered digitally.

Corbis
www.corbis.com

Corbis is one of the major players in stock photography sales. It is the brain child of Bill Gates, and his collection has grown into one of the leading collections of images in the world. It's another good place to see the best in stock photography.

PunchStock
www.punchstock.com

This web site features images from more than a hundred of the leading stock photography organizations throughout the world (BananaStock, Blue Jean Images, Comstock, Corbis, UpperCut, etc.). It's a great place to surf through images from all of these agencies—to see what's selling in your specialty and in your markets.

National Geographic Society
www.nationalgeographic.com

Long the leader in creating socially and ecologically conscious photojournalism, the National Geographic Society has a very good web site. It contains a lot of information and examples by their leading photographers. This is a good place to learn about the very best in the publishing and the photography world. All of the many National Geographic publications, books, DVD programs, maps, globes, clothing—and a lot more—can be found in this site.

Internal Revenue Service
www.IRS.gov

The Internal Revenue Service is the best source of independent business tax information available. While this should come as no surprise, many independent businesspeople overlook it as a resource. Their extensive library of guides are aimed at helping freelance businesses comply with complicated tax requirements, which you must do to be successful. Its booklets are ready-made accounting guides for all aspects of a good financial filing system. The smart self-employed businessperson will take advantage of this invaluable free resource. A few suggested IRS publications every freelancer should read include: *Tax Guide for Small Business; Starting a Business and Keeping Records; Business Expenses; Business Use of Your Home; Business Use of a Car; Travel, Entertainment and Gift Expenses;* and *Your Rights as a Taxpayer.*

Agency Access
www.agencyaccess.com

Agency Access is the perfect place to develop good client lists. It is a simple web site that allows you to create cus-

tomized listings for a wide variety of photography buyers and users. They make it easy to select the specific publications or organizations, as well as the type of buyer or user inside that organization. They provide street addresses, phone numbers, and e-mail contact information in addition to a full range of design, printing, and mailing services. An excellent starting list can be created for under $100.00.

U. S. Small Business Administration (SBA)
www.sba.gov

The SBA is an independent, tax payer–funded agency that provides support to businesses with under a thousand employees. It helps people start, build, and grow businesses through an extensive network of field offices and partnerships with public and private organizations throughout the United States, Puerto Rico, U. S. Virgin Islands, and Guam. The organization's help comes in the form of mentors, financial services and loans, advice on starting and running a business, and a host of other things too numerous to mention here. The SBA also helps small businesses and families recover from economic (and other) disasters.

U. S. Copyright Office
www.copyright.gov

For the best protection, you should register the copyright to your images with the federal government. Complete information on this process is available from the Copyright Office. You can also download any copyright form and instructions from its web site.

Blossom Publishing
www.blossom-publishing.com

Blossom Publishing is a printing company that specializes in advertising agency–quality postcards, magazines, brochures, and catalogs. They offer products from as few as fifty to several thousand copies. They provide a very nice sales package of products, samples, and designs. Digital press–printed products, web design, mail-house services, and client list management services are also available.

Black Tie Press/H&H Color Lab
www.hhcolorlab.com

H&H Color Lab has been in the business of producing print materials for film photographers for more than thirty years. They have embraced the digital world, as well, offering several traditional printing press–type products through their subsidiary Black Tie Press. Their products include hard- and soft-cover books, posters, calendars, business cards, newsletters, and brochures. Their hardback books are also an excellent and easy way to become a published author. They have a several educational programs, both location and online, that help photographers learn how to utilize their products and services.

Apple Store
www.store.apple.com

This site features everything in the world of Apple—Mac computers, iPhones, iPods, Apple TV, software, accessories, and probably a lot more being developed every day. If you're interested in a particular product, this is the place to learn the exact specifics and costs.

B&H Photo
www.bhphotovideo.com

B&H is one of the very best sources for just about anything and everything that's used in a freelance digital photography business—photo equipment, computer hardware and software, audio and video equipment, and a lot more. Their online store has more than 170,000 items available for immediate shipment every business day. B&H has been in business for more than thirty years, earning an excellent reputation for service and knowledge of the products they sell. In addition to their extensive online catalog, they have a well-stocked—and well-staffed—store in New York City.

MacMall
www.macmall.com

MacMall is good place to find the latest equipment and software—not to mention some good prices and even better sales—for everything in and supported by the Apple family. Their customer service people are also good resources about what will work best for your needs.

The Black Book
www.blackbook.com

This is a leading advertising and assignment resource for finding photographers. In addition to publishing a quality book, they also offer online portfolios, client resources, and several other professional services. They are a trusted source for creative talent, both nationally and internationally, publishing six annual resource books that feature images by talent from around the world. This is a very good place to display your work—and a very good place to see the work of top professionals.

FTP Worldwide
www.ftpworldwide.com

As your business grows, and your clients' files get larger, you will need a transfer service to manage everything. FTP Worldwide provides online file transfer services of very large image files. They also help solve photographers' problems with attachment-size limitations, system-resource drains, security, and data corruptions.

Workshops and Seminars

We can't say enough about learning freelance photography from successful people already established in your specialty (or from related areas of interest). One of the best ways to do this is through the thousands of excellent photography workshops, seminars, and adventure programs given by successful professionals. These programs range from a couple of hours through local camera shops and photo clubs, to international conventions presented by major magazines and manufacturers. A few of the very best programs are listed here—and you can Google any specialty followed by "photo workshop" to find a lot more choices. Most of the better seminars, workshops, and advanced schools are in locations that are also ideal for creating beautiful photography.

PhotoPlus International Conference and Expo
www.photoplusexpo.com

This is easily the largest gathering of photography-related creators, manufacturers, and publishers under a single roof. You'll find some of the very best seminars by leading professionals at this conference, along with workshops by the best businesspeople—in addition to a huge tradeshow. Attending this event is one of the best investments that aspiring and established photographers can make. Check out the web site and ask to be put on the mailing list for a catalog of dates, events, and participants.

The Palm Springs Photo Festival
www.palmspringsphotofestival.com

This annual festival offers a multitude of fun photographic workshops, seminars, symposiums, portfolio reviews, evening presentations, and related events. Beyond the programs, there are a lot of opportunities to mingle with some of the world's best photographers, magazine editors, museum curators, art directors, and educators at informal social gatherings. The evening programs are followed by get-togethers in the Palm Springs Art Museum gardens, where they feature tastings from California winemakers. Some very nice prizes are also awarded in its annual photo contest.

Santa Fe Photographic Workshops
www.santafeworkshops.com

The Santa Fe Photographic Workshops are a year-round, inspirational resource for photographers from all walks of the profession. Most of the programs are conducted in and around their beautiful New Mexico campus, although they also offer several travel-oriented programs in photogenic locations such as Barcelona, Bangkok, Tuscany, Venice, Provence, Vermont, Mexico, Hawaii and Australia. Their visiting lecturers are as diverse as the subjects they cover, including such outstanding photographers as David Allen Harvey, Jim Richardson, Jay Maisel, David Middleton, John Weissand, Joe McNally, and Gregory Heisler.

Maine Media Workshops
www.theworkshops.com

The Maine Media Workshops offer an excellent opportunity to visit a beautiful environment and to learn from a community of high-quality image-makers and storytellers. This is a good place to see talented photographers and their working styles up close—as well as to shoot alongside them in the field. Participants always come

away with an amazing appreciation for the programs, speakers, staff, hospitality, and location. An extensive seminar and course catalog is available.

Sundance Photographic Workshop
www.sundanceworkshop.com

Sundance offers a comprehensive series of workshops presented by leading photographers who excel in their specialty and are acclaimed teachers. The curriculum begins with a thorough review of the equipment and its proper handling, and then proceeds into the chosen subjects with a combination of classwork, field and studio shooting, and one-on-one instruction. Class sizes are limited to approximately fifteen people, and enrollees also benefit from evening presentations by course instructors in other subject areas, providing an overview of the entire active curriculum. Their programs are held in Sundance, UT, which is surrounded by a breathtaking natural environment and a community dedicated to the creative arts.

Bob Krist Workshops
www.bobkrist.com/schedule.php

Freelance travel photographer Bob Krist, who works regularly for magazines such as *National Geographic Traveler, Smithsonian,* and *Islands,* presents some very good location workshops. His programs include such things as exploring the Baltic's historic waterways from St. Petersburg to Copenhagen aboard the National Geographic Society's ship Endeavour, weekends sponsored by *Outdoor Photographer* magazine in Milwaukee, and a truly ultimate private-jet expedition of Africa—from the remote islands of the Seychelles, to wildlife in secluded jungles, to the Maasai of the Serengeti, to the remote coastal forests of Madagascar and Cape Town.

National Geographic Traveler Seminars
www.ngtravelerseminars.com

National Geographic Traveler is a travel photography–oriented sister publication to *National Geographic.* Accordingly, their seminars feature some of the best travel photographers in the world. Seminars are offered in several major cities across the country and usually take place over a weekend.

National Geographic Expeditions
www.nationalgeographicexpeditions.com

National Geographic Expeditions are a huge resource for travelers and photographers alike. While only a few of their journeys are aimed specifically at photographers, all of their programs are ideal for making beautiful photography. Their catalog of programs and locations is also an inspiration to photographers. Always a leader in quality photography, the National Geographic Society also links to a calendar of events providing information on upcoming photo and travel workshops/expeditions, led by their very talented photographers.

Brooks Institute
www.brooks.edu

Brooks is an outstanding professional school that offers training in photography, photojournalism, filmmaking, and graphic design—including a degree in the technique and art of photography. The school has beautiful locations in Santa Barbara and Ventura, California. Many of today's leading photographers began their successful careers at Brooks.

Academy of Art University
www.academyart.edu

Located in the heart of San Francisco, one of the most photographed places in the world, the Academy of Art is the largest private school of art and design in the country. It offers studies in traditional and digital photography, including fashion, advertising, editorial, fine art, black & white, documentary, photojournalism, and portraiture. The university also offers classes and degrees through an excellent online program.

The Art Institute of Seattle
www.ais.edu

This is a very good, hands-on higher education for a wide variety of arts, including photography and video production. Many programs are available from experienced professors, including fine-art degrees. Students present their portfolios on a regular basis to leading photographers, art buyers, advertising agencies, and publishers from the region.

Brown College
www.browncollege.edu

Brown College has an excellent program leading to a BS in digital photography, with additional emphasis and photography career studies in advertising, documentary, commercial, event, fashion, fine-art, news, police, portrait, sports, and stock photography, along with visual communications and television production. It's located in beautiful Mendota Heights, Minnesota, making it ideal for studying and creating photography.

Briarcliffe College
www.bcbeth.com

Briarcliffe offers a complete business photography program, including an AAS in digital photography. Their programs feature commercial photography, photographic editing, portrait photography, new media art, freelance photography, and advanced digital techniques in photographic reproduction. They have campuses in Bethpage and Long Island City, New York.

Internet Forums

Exchanging ideas, sharing experiences, reviewing equipment, and asking and answering questions are the primary functions of online photography forums. These are tremendous resources for learning and expanding a photographer's interest in almost any general or specific area of knowledge. There are hundreds of forums available—probably thousands. The following sites are just a sample of what can be found with a Google search of your interests and specialties.

The PhotoForum
www.thephotoforum.com/forum/

This is an international community of photographers, from beginners to professionals, including film shooters and digital shooters. This site is informative, educational, and a friendly place to discuss all aspects of photography, as well as a place to share images.

Canon Digital Photography Forums
www.photography-on-the.net/forum/

This is the place for digital camera enthusiasts using Canon cameras. These forums also cover general photography and technique discussion areas that are not camera-specific.

Digital Photography Review
www.dpreview.com/forums/

This was among the very first discussion and review forums established for digital photography. Interested visitors can discuss, ask questions, or generally debate anything related to digital photography, digital cameras, or digital imaging technology.

Open Photography Forums
www.openphotographyforums.com/

This open forum, for professional and enthusiast photographers worldwide, contains up-to-date discussions on technology, creativity, function, and other issues, all of which are moderated and reviewed by expert photographers. They bill themselves as a community of photographers with real names, common interests, and experience, dedicated to the working professional and the creative mind.

Digital Photography
www.photozo.com/forum/

This is a digital photography community for photographers of all skill levels to share knowledge, get critiques on photos, and discuss techniques.

The Photo Net Community
www.photo.net/community/

A group of thirty-three different photography forums with more than 3,000 new posts added daily, this site contains a huge array of photography information covering nearly every aspect of every specialty, equipment, business, education, and philosophy.

The PopPhoto Forum
forums.popphoto.com/

The home of *Popular Photography* and *American Photo* magazine forums, this site contains everything from technical aspects of photography, to equipment, reviews, portfolios, swap meets, and rants and raves. It has an excellent message room as well.

Nikonians
www.nikonians.org

A place to find general and specific information about Nikon products and equipment, this is a top-tier reference site helping digital and film photographers to shorten their individual learning curve and to improve their own photography skills and results—all while making long-lasting friendships across national borders and continents.

Nikon Pro
www.nikonpro.com

This is a premium service and resource for professional Nikon photographers in every segment of the business. They are best known for intensive coverage of field events, providing loaner equipment, access and shooting assistance, and their international priority repair service. Membership is available only to bona fide full-time professional photographers who own Nikon equipment. There is no charge for membership.

Professional Wedding Photographers Forum
www.pwpforums.com/

This is a professional forum dedicated to supporting established and aspiring wedding photographers. They offer live seminars, networking events, and other professional resources. Currently, PWP hosts a message board with fifteen-hundred working professional-photographer members and a number of industry vendors and supporters, whose membership spans the globe.

Writers Marketplace
www.writersmarketplace.com

This is the connection for travel media professionals, including writers, photographers, PR firms, and publications involved in the world of travel. It was developed primarily for Society of American Travel Writers members, however non-members have access to several informative sections.

PhotographySites.com
www.photographysites.com

PhotographySites.com is an excellent collection of online photo galleries, web sites, and forums designed to promote the exchange of information and images among similar types of online photo galleries. There are several sites categorized into themes such as landscape, nature, wildlife, fine art, travel, documentary, digital stock, etc. They accept personal gallery sites in all of these areas. This is a very good place to exchange shooting ideas and find other freelancers interested in your specialty.

Ken Rockwell Forum
www.kenrockwell.com

This is an eclectic collection from photographer Ken Rockwell's fertile mind and cameras. It rambles around through equipment reviews, workshops, galleries, books, cars, and Rockwell's equally eclectic family. This is a fun place to learn about homegrown photography, along with some very solid information on equipment, shooting, and locations.

Digital Wedding Forum
www.digitalweddingforum.com

This is a huge collection of member exchange forums, galleries, general information, seminar listings, newsletters, and equipment discounts for wedding (and, to some degree, portrait) photography. It's a good place to keep up with current industry trends, as well as learning techniques from some of the best in the business.

Strobist
www.strobist.blogspot.com

A place to find and learn everything a mobile freelancer needs to know about using off-camera flash with a digital camera system. Features some very good secrets and techniques, in addition to lighting courses, equipment reviews, book recommendations, and photographer exchanges.

Software

As with all of the resources in this section, there are thousands of software products available for freelance digital photographers. The ones listed here are among those we think are the best and most important.

Adobe Photoshop
www.adobe.com

Photoshop is the standard by which all digital image manipulation, retouching, correction, and creation is measured. In experienced hands, it is pure magic when completing these tasks. It is indispensible to the working professional photographer.

Apple iPhoto
www.apple.com/ilife/iphoto

iPhoto is a good basic program to deal with digital images, make prints, create slide shows, file photos by subject, and do some image correction. This software comes installed with most new Apple computers, which makes it one of the best places for starting photographers to learn about image management and manipulation.

Adobe Bridge
www.adobe.com/products/creativesuite/bridge

Bridge is an image-management program that comes, at no additional cost, with Adobe Photoshop. It offers functions like batch renaming, image rating, and more. It is generally the choice of professionals who prefer moving large numbers of images into Photoshop, where the manipulation and corrections are more advanced and subtle than in management programs.

Adobe Photoshop Lightroom
www.adobe.com/products/photoshoplightroom

Photoshop Lightroom is a good program that helps photographers in viewing, editing, and making some corrections to large volumes of digital images. It works with the Adobe Photoshop software by handling the simpler work quickly. It shares many of the same capabilities as Apple Aperture and is also excellent for producing slideshows and prints—and, in some versions, building web pages.

Apple Aperture
www.apple.com/aperture

Aperture helps photographers view, edit, and make basic corrections to large volumes of digital images. It shares many of the same capabilities as Adobe Photoshop Lightroom. Among the file management tasks it handles are contact-sheet printing, smart album production, watermark placement, and the export of images to more complex programs, like Adobe Photoshop.

Microsoft Expression
www.microsoft.com/expression

Expression enables you to create visual databases of most kinds of digital media, in thousands of files per document. Those files can be stored in shared folders, CDs, hard drives, or DVDs. Integrated search tools can find them in seconds. It is an excellent stock photography tool.

Fetch
www.fetchsoftworks.com

Fetch is an excellent Mac-based program that is ideal for transferring large image files over the Internet. It can also be used to publish web sites, transfer documents to a printing company, submit advertisements to print media, and publish images for eBay auctions. The program uses the File Transfer Protocol (FTP) or SSH File Transfer Protocol (SFTP) standard.

Microsoft Office
www.office.microsoft.com

Microsoft Office is a powerful suite of business-oriented programs including Word (word processing), Excel (spreadsheets), PowerPoint (visual presentations), Messenger (online communications), Entourage (an extensive e-mail program), and calendar tools. Microsoft Office is one of the most versatile and complete packages available for an independent business of any size.

QuickBooks and TurboTax
www.intuit.com

Intuit's QuickBooks is ideal when it comes to record-keeping, expense-tracking, printing checks, paying bills, creating estimates and invoices, tracking sales, creating forms, printing 1099s, and exporting your financial information to a tax-filing program. TurboTax, also by Intuit, blends nicely with simple-to-use online filing of state and federal taxes for home and small businesses. It covers such important things as self-employment tax, small business tax, tips, and offers very good help with determining your tax deductions.

Professional Associations

Professional associations, and their related social organizations, are one of the best places to meet with, and learn from, freelance digital photographers who share your goals, interests, and specialties. There are hundreds of associations that welcome new members and help them with educational programs, workshops, social meetings, sponsor events, and competitions.

A few associations, on the other hand, have formed under the pretense of being a professional organization, but are, in practice, only interested in selling memberships and products. Always read the membership and participation requirements carefully—and try to get recommendations from members in your local area.

In reading through some of the associations listed in this section, you'll notice a few are composed solely of established working professionals and have stringent membership requirements. Even if you do not meet these requirements at the moment, these organizations are still one of the best places to see what's required to be a working professional in their specialty. Their members also frequently give workshops open to the general photography public and write books that are usually excellent resources, as well. Some of this information may also be available on their sites to non-members.

Advertising Photographers of America (APA)
www.apanational.com

APA's goal is to establish, endorse, and promote professional practices, standards, and ethics in the photographic and advertising community. Members mentor, motivate, educate, and inspire each other in the pursuit of excellence. They are composed of established working professionals and have stringent membership requirements.

Professional Aerial Photographers Association (PAPA)
www.papainternational.org

The Professional Aerial Photographers' Association (PAPA) is a professional trade organization comprised of aerial photographers throughout the world. PAPA is dedicated to exceptional business ethics, helping members provide quality service, cultivating friendship and mutual understanding among colleagues, and promoting excellence through business education and creative photographic expertise through seminars, meetings and workshops. Their members utilize airplanes, helicopters, balloons or elevated platforms to create aerial images.

International Society for Aviation Photography (ISAP)
www.aviationphotographers.org

The ISAP is an international, non-profit society whose members span a wide variety of professional fields, including professional and amateur photographers, writers, historians, publishers, trade representatives, and pilots. Membership offers the opportunity to learn from some of most talented professionals in the aviation photography industry.

International Association of Architectural Photographers (IAAP)
www.architecturalphotographers.com

The IAAP is a top-rated resource and an international online community where architectural photographers from all over the world can meet, share ideas, and enhance their business.

Association of Independent Architectural Photographers (AIAP)
www.aiap.net

The Association of Independent Architectural Photographers (AIAP) is an international organization dedicated to promoting the professional success of full-time architectural photographers. Members observe a strict code of ethics that promotes worldwide professionalism, cooperation, and respect among fellow photographers and photography buyers.

Cowboy Artists and Photographers of America (CPAI)
www.cowboyphotographersandartistsinternational.org

Cowboy Photographers and Artists International is an professional organization designed for cowboy, western, and rodeo artists and photographers from around the world. This organization offers a place for artist networking, while at the same time promoting the work of members to private, business, and government art buyers. It is composed of established working professionals and has stringent membership requirements.

Editorial Photographers (EP)
www.editorialphoto.com

This organization is dedicated to improving the health and profitability of editorial photography and photographers. Its stated mission is to educate photographers and photo buyers about business issues affecting our industry—and, in the process, raise the level of business practices in the profession.

Evidence Photographers International Council (EPIC)
www.epic-photo.org

EPIC is a non-profit educational and scientific organization dedicated to the advancement of forensic photography and videography in civil evidence and law enforcement. It provides members with education and resources to aid in the advancement of evidence photography. Programs also promote development of member skills and knowledge, from the leading evidence photographers working today.

The International Association for Identification (IAI)
www.theiai.org

This wide-ranging group includes professionals within several associated specialties of law enforcement, evidence gathering, photography, and identification.

Freefall Photographers Association
www.3.sympatico.ca/keith.takayesu/ffpa/

Members of this organization are in one of the most exciting and elite fields of photography. All of its members are accomplished skydivers first, and accomplished photographers second. Safety, education, and creativity are among the benefits of membership. (For the record, parachuting is safer than scuba diving.)

International Glamour Photographers Association (IGPA)
www.internationalglamourphotographers.com

An association of professional glamour, figure, swimsuit, fashion, pin-up, and fine art nude photographers, this is a place to learn about the business and creative sides of this popular area of freelance photography. There are also multiple sites available, on its home page, advertising the services of professional models, stylists, studios, and related glamour services.

International Industrial Photographers Association (IIPA)
www.industrialphotographers.net

This is an international organization for established professionals that educates, communicates, and promotes industrial photography.

American Society of Media Photographers (ASMP)
www.asmp.org

ASMP is the foremost international organization aimed at editorial, stock, and other media-related photographers who create images primarily for publication. Its members are some of the leading proponents for photographers' rights, rates, and copyright protections in all freelance specialties. It has excellent associate and student memberships available, accompanied by a wide variety of development programs for all levels and abilities. Its membership requirements are stringent.

North American Nature Photographers Association (NANPA)
www.nanpa.org

NANPA is the leading organization of professional outdoor, nature, and wildlife photographers. It provides education, fosters professionalism and ethical conduct, gathers and disseminates information, and develops standards for all persons interested in the field of nature photography.

International Association of Panoramic Photographers (IAPP)
www.panphoto.com

The popular specialty of panoramic photography is represented by this long-standing organization. Visitors from all professions and walks of life are welcome at its official web site.

Photographic Society of America (PSA)
www.psa-photo.org

A worldwide, interactive organization for anyone interested in photography—from the casual shooters, to serious amateurs, to working professionals. Individuals, camera clubs, chapters, and council members are offered a wide variety of activities, a monthly magazine, competitions, study groups via mail and the Internet, how-to

programs, an annual conference, and many other activities and services.

American Society of Picture Professionals (ASPP)
www.aspp.com

The primary umbrella organization that brings together all persons involved within the photographic profession, the society provides a forum about the use, purchase, and sale of still images; promotes high professional standards; maintains a "Code of Fair Practice" in the business of picture research and handling; and cooperates with organizations that have similar interests.

National Press Photographers Association (NPPA)
www.nppa.org

Membership in NPPA is essential for news photojournalists, television video shooters, and their related editors and publishers. It is aimed at both freelance and staff photographers. This association provides lots of educational programs, competitions, and benefits for shooters, writers, editors, and television newspeople, alike. It is composed entirely of established working professionals and have stringent membership requirements.

Professional Photographers of America (PPA)
www.ppa.com

This is one of the largest, oldest, and most diverse professional international photography associations in the world. Membership is aimed at all aspects of commercial photography, especially portrait, wedding, commercial businesses, and retail photo sales. The organization offers hundreds of seminars, lectures, educational programs, and competitions.

Society of Sports and Events Photographers (SEP)
www.sepsociety.com

More properly called the International Association of Professional Event Photographers, SEP's mission is to provide its members the education, market resources, and material resources necessary to help them become competent and successful sports photographers.

Sport Photographers Association of America (SPAA)
www.pmai.org/content.aspx?id=4772

SPAA is committed to providing educational programs, industry research, business services, networking, and events to further drive the success and credibility of its members.

Stock Artists Alliance (SAA)
www.stockartistsalliance.org

SAA is the only photography trade association focused on the business of stock photography. SAA supports its members with exclusive benefits to support their stock businesses and keeps them up to date so they can make informed choices as they adapt to changes and challenges in today's marketplace. They also offer eNews updates, member briefings, a private discussion forum, an ombudsman program with stock distributors, investigative projects, legal support, and material discounts.

Society of American Travel Writers (SATW)
www.satw.org

The leading international organization of travel communicators, including travel writers, photographers, film makers, broadcasters, editors, publishers, speakers and travel public relations professionals. SATW is the best in the travel business, offering many professional development programs, publications, workshops and conferences. It is composed of established working professionals and has very stringent membership requirements.

Scubalinx
www.scubalinx.com

This is a general place to search out organizations that support underwater photography. We also highly suggest becoming associated with one of the professional diving-instructor associations, which offer excellent certification programs in basic scuba diving, photography, safety, and other sport-diving specialties. We recommend the Professional Association of Diving Instructors (www.padi.com/padi/en/footerlinks/contactus.aspx) and the National Association of Underwater Instructors (www.naui.org).

British Society of Underwater Photographers (BSUP)

www.bsoup.org

This is an excellent international association for the exchange of ideas and information about underwater photography. The society is dedicated to encouraging and developing underwater photography in all its aspects. Its members vary from beginners to eminent professionals.

Underwater Photographic Societies

There are dozens of underwater photographic societies around the world. If you want to learn about underwater photography in a particular area, we suggest joining the society in that area. Their web sites offer a huge amount of information about local dive sites, equipment rentals, member galleries, and potential diving partners. A few underwater photographic societies include Hawaii (www.upsh.org); Kona, Hawaii (www.kups.org); Maui, Hawaii (www.mupsonline.org); San Diego, California (www.sdups.com); South Florida (www.sfups.org); and Western Australia (www.waups.org.au).

International Virtual Reality (VR) Photography Association

www.ivrpa.org

The Virtual Reality Photo Association is an international organization of photographers, web designers, manufacturers, and artists who seek to promote the use and application of 360-degree photographic VR images. They invite interested photographers to take a spin in their world.

Glossary

Advertisement—A paid sales message, generally seen in newspapers, magazines, web sites, and on television programming.

Agreement—An understanding or arrangement, usually written, between two or more people/businesses. *See also* Contract *and* Oral contract.

Audit—An accounting of all your business finances, usually conducted by a governmental body or your CPA.

Bid—The price at which you offer to create an image or to do a specific job or service.

Bottom line—The final total cost of a project.

Business plan—An outline of your photographic, marketing, and business capabilities—and how you plan to use them in a new business.

Capital—Money. Usually an investment in a business venture.

CD/DVD—Types of computer discs used to store photo images, music, and documents.

Client—A business or person that hires you and pays you for a specific service or product.

Confirmation letter—A letter you send to clients listing the specific details of an upcoming assignment.

Contract—An agreement, usually in writing, to perform specific services or to sell specific products at a stated price. *See also* Agreement *and* Oral contract.

Copyright—The ownership of an image or other creative item.

CPA—Certified Public Accountant.

Documentation—The paperwork accompanying an assignment, photo sale, business, or tax form.

Editorial—Generally refers to newspaper, magazine, television, and web-site information and photography.

Enhance—Improve the look and quality of an image.

Entrepreneur—A businessperson who establishes and manages a business, assuming the potential risks in exchange for potential profit.

Estimate—What you think the approximate costs will be for a job or image.

Excel, Microsoft—A computer program for financial budgeting, forecasting, and planning. Usually part of the Microsoft Office Suite of programs.

Federal ID—An identification number provided to businesses by the federal government.

Field—The area of photography in which a person is engaged. Also called a specialty.

Fine print—The legally important small print on the back of checks, memos, forms, and related business papers.

Flyer—A printed advertisement or information sheet about your services and products, sent to prospective clients.

FTP (File Transfer Protocol)—A way to transfer data, including large image files, from one computer to another over the Internet.

Gross—The total income from a business, or individual sale, before expenses and taxes have been subtracted.

Gyro—A camera-stabilization device, generally used when shooting aerials or from other moving transportation.

Hand-shake agreement—*See* Oral contract.

Hardware—The computer, screen, printer, scanner, and similar equipment.

Hobby photo income—Selling your services or photos, mostly for fun, while employed in a regular job or retired.

IRS (Internal Revenue Service)—The federal bureau that regulates and collects income taxes.

Lease—Renting equipment or property for a specific time.

LLC (Limited Liability Company)—A legal business format.

Location shoot—A shoot that takes place away from your office or studio.

Manipulation of photos—Enhancements, alterations, and other adjustments made to a photographic image, generally on a computer with Adobe Photoshop software.

Market—An industry or general field in which products or services are sold.

Marketing—The process of planning where, when, and how to sell your products and services.

Media—Newspapers, magazines, newsletters, radio, television, and web sites that disseminate information to a public or private audience.

Media release—*See* News release.

Model release—Written permission to use and/or sell images you have produced of a specific person. Must be signed by the person or the legal guardian of minor children.

News release—An article and photo, promoting your business activities, that is sent to any media outlet.

Oral contract—A spoken (not written) agreement to perform services or sell products. Also referred to as a hand-shake agreement.

Overhead—The cost to be in business (usually figured on a monthly basis) excluding specific job or project expenses. Includes such things as utilities, phone, rent, insurance, postage, and wages.

Photo system—Cameras, lenses, and related accessories produced by the same manufacturer.

Photoshop, Adobe—An excellent computer program used to enhance or manipulate images.

Portfolio—A collection of images presented to clients in the hopes of making sales.

Price—The cost for a product or service.

Profit—The amount left over when all the job-related expenses have been subtracted from your gross income.

Property release—Written permission to use or sell images you have made of a specific property or item. Must be signed by the owner.

QuickBooks, Intuit—A computer program for managing checkbooks and other financial accounts. This coordinates with TurboTax for tax preparation and filing.

Quote—The price you guarantee for an image or a specific job.

Rate—The price charged or quoted for products or services. Usually specified hourly, daily, or by the project.

Reputation—What others, usually clients, think of your work.

Resume—A listing of business and work experiences, education, and other related information. Generally used to seek employment.

SBA (Small Business Administration)—An independent, tax-funded angency that provides support to small businesses.

Selling—Contacting clients to present your products and services. Also known as knocking on doors, sending e-mails, mailing printed materials, and making phone calls.

Small business—Any business with less than a thousand employees. Also called an independent business.

Software—Programs that operate within a computer system to perform a specific task.

Sole proprietor—Small business operated by single person, often with their spouse, that files taxes with personal tax forms.

Style—The look and character of your photography.

Subcontractor—A person who completes a portion of a service or product that has been contracted to another person or company. A photographer's freelance assistant, who has their own business, is a subcontractor.

Supplier—A business or person that provides services or products to another business or person. Photographers are often called suppliers by their clients.

Tax ID—A number given by the federal government, states, and cities, which helps them determine when, and to whom, a business charges or pays various taxes. The federal government calls your social security number a tax ID.

Transparency—General term for a large-format slide. A 35mm slide is also a transparency.

TurboTax, Intuit—A computer program for tax preparation and filing. This coordinates with QuickBooks for managing checkbooks and financial accounts.

Web site—A promotional or informational page on the World Wide Web, also known as the Internet.

Word, Microsoft—An excellent computer program for word processing (writing).

Work for hire—A contract under which you perform exactly the service required by a contractor who usually retains all or specific rights to the final materials.

World Wide Web—A system of information, products, and resources that can be accessed with a computer and related software.

Index

SCULPTING WITH LIGHT

Allison Earnest

Learn how to design the lighting effect that will best flatter your subject. Studio and location lighting setups are covered in detail with an assortment of helpful variations provided for each shot. $34.95 list, 8.5x11, 128p, 175 color images, diagrams, index, order no. 1867.

STEP-BY-STEP WEDDING PHOTOGRAPHY

Damon Tucci

Deliver the top-quality images that your clients demand with the tips in this essential book. Tucci shows you how to become more creative, more efficient, and more successful. $34.95 list, 8.5x11, 128p, 175 color images, index, order no. 1868.

ROLANDO GOMEZ'S
POSING TECHNIQUES FOR GLAMOUR PHOTOGRAPHY

Learn everything you need to pose a subject—from head to toe. Gomez covers each area of the body in detail, showing you how to address common problems and create a flattering look. $34.95 list, 8.5x11, 128p, 110 color images, index, order no. 1869.

PROFESSIONAL WEDDING PHOTOGRAPHY

Lou Jacobs Jr.

Jacobs explores techniques and images from over a dozen top professional wedding photographers in this revealing book, taking you behind the scenes and into the minds of the masters. $34.95 list, 8.5x11, 128p, 175 color images, index, order no. 2004.

THE ART OF CHILDREN'S PORTRAIT PHOTOGRAPHY

Tamara Lackey

Learn how to create images that are focused on emotion, relationships, and storytelling. Lackey shows you how to engage children, conduct fun and efficient sessions, and deliver images that parents will cherish. $34.95 list, 8.5x11, 128p, 240 color images, index, order no. 1870.

EVENT PHOTOGRAPHY HANDBOOK

W. Folsom and J. Goodridge

Learn how to win clients and create outstanding images of award ceremonies, grand openings, political and corporate functions, and other special occasions. $34.95 list, 8.5x11, 128p, 150 color images, index, order no. 1871.

50 LIGHTING SETUPS FOR PORTRAIT PHOTOGRAPHERS

Steven H. Begleiter

Filled with unique portraits and lighting diagrams, plus the "recipe" for creating each one, this book is an indispensible resource you'll rely on for a wide range of portrait situations and subjects. $34.95 list, 8.5x11, 128p, 150 color images and diagrams, index, order no. 1872.

DIGITAL PHOTOGRAPHY BOOT CAMP, 2nd Ed.

Kevin Kubota

This popular book based on Kevin Kubota's sell-out workshop series is now fully updated with techniques for Adobe Photoshop and Lightroom. It's a down-and-dirty, step-by-step course for professionals! $34.95 list, 8.5x11, 128p, 220 color images, index, order no. 1873.

LIGHTING AND PHOTOGRAPHING
TRANSPARENT AND TRANSLUCENT SURFACES

Dr. Glenn Rand

Learn to photograph glass, water, and other tricky surfaces in the studio or on location. $34.95 list, 8.5x11, 128p, 125 color images, diagrams, index, order no. 1874.

100 TECHNIQUES FOR PROFESSIONAL WEDDING PHOTOGRAPHERS

Bill Hurter

Top photographers provide tips for becoming a better shooter—from optimizing your gear, to capturing perfect moments, to streamlining your workflow. $34.95 list, 8.5x11, 128p, 180 color images and diagrams, index, order no. 1875.

BUTTERFLY PHOTOGRAPHER'S HANDBOOK

William B. Folsom

Learn how to locate butterflies, approach without disturbing them, and capture spectacular, detailed images. $34.95 list, 8.5x11, 128p, 175 color images, index, order no. 1877.

DOUG BOX'S
GUIDE TO POSING

FOR PORTRAIT PHOTOGRAPHERS

Based on Doug Box's popular workshops for professional photographers, this visually intensive book allows you to quickly master the skills needed to pose men, women, children, and groups. $34.95 list, 8.5x11, 128p, 200 color images, index, order no. 1878.

500 POSES FOR PHOTOGRAPHING WOMEN

Michelle Perkins

A vast assortment of inspiring images, from head-and-shoulders to full-length portraits, and classic to contemporary styles—perfect for when you need a little shot of inspiration to create a new pose. $34.95 list, 8.5x11, 128p, 500 color images, order no. 1879.

POWER MARKETING, SELLING, AND PRICING

A BUSINESS GUIDE FOR WEDDING AND PORTRAIT PHOTOGRAPHERS, 2ND ED.

Mitche Graf

Master the skills you need to take control of your business, boost your bottom line, and build the life you want. $34.95 list, 8.5x11, 144p, 90 color images, index, order no. 1876.

MINIMALIST LIGHTING

PROFESSIONAL TECHNIQUES FOR STUDIO PHOTOGRAPHY

Kirk Tuck

Learn how technological advances have made it easy and inexpensive to set up your own studio for portrait photography, commercial photography, and more. $34.95 list, 8.5x11, 128p, 190 color images and diagrams, index, order no. 1880.

MASTER POSING GUIDE FOR WEDDING PHOTOGRAPHERS

Bill Hurter

Learn a balanced approach to wedding posing and create images that make your clients look their very best while still reflecting the spontaneity and joy of the event. $34.95 list, 8.5x11, 128p, 180 color images and diagrams, index, order no. 1881.

Also by Cliff Hollenbeck

Big Bucks Selling Your Photography, 4TH EDITION

Learn how to make big money as a photographer and how to handle the financial aspects of your business when those checks start rolling in. This book offers the advice you need to secure funding, attract clients, stay out of legal trouble, and rake in the dough. You'll learn how to create a sound business plan, how and when to apply for copyrights, how to set and collect fair rates, and much more. You'll also discover what it takes to create a portfolio that speaks to potential clients, and how to sell yourself and your images. Because the government requires a cut of your earnings, you'll also learn just what is required of you at tax time, how to determine what qualifies as a tax deduction, and how to deal with audits. With forms you can copy for your personal use and updated information on copyright protection in the digital age, this book is a perfect resource for everyone! $34.95 list, 8.5x11, 144p, sample forms and letters, index, order no. 1856.